COMPANIONS OF THE ROAD

PETER PELIKAN · PETER DRESSLER · WOLFGANG SEIDEL ·
ALFRED SCHMIED · ZANASCHKA · CLAUDIO BARBATO ·
ALBERTO DELLA VECCHIA · SIEGFRIED POPPE · FERRY RADAX ·
JEAN ABERBACH · EFTHYMIOS WARLAMIS ·
BOGU BILINSKI · FRIEDR. GULDA · BERND WÖRNER ·
JORAM HARTH ... SCHMIED ·
WALTER KO... ... ERT SCHEDEWY ·
SIMONE ET ... ANDIARGUES ·
BABS UND P... ...ILIO CASAGRANDE ·
ELVIO CASAGRA... ...CHARD SMART ·
HORST WÄCHTER · HANS N... ... ANDREW FAGAN ·
PETER, CRAIG, GABRIELLE, GIL FAGAN · RAYMOND CORDIER ·
JEANETTE ET PAUL FACCHETTI · OTTILIA ITEN · REINHOLD JAKSCH ·
FRANZ BISCHOF · SZANDOR BELSZAK · SHINKICHI TAJIRI ·
RENÉ BRO? · ARIK BRAUER · ERNST FUCHS · ARNULF RAINER ·
CHRISTIAN HUNZIKER · DAVID KUNG · LEOPOLD SEDAR SENGHOR ·
FAMILLE DUMAGE : SUZANNE, AUGUSTIN, MADELAINE, MARIA ·
TISCHLER NEULINGER · CAPITANO ANTONIO · ROBERT ROGNER ·
WOLFGANG WACHENDORFF · PLATTENSTEINER · MUHR FRANZ ·
REINHARD ARTBERG · ELFI KOLLER · UDO PROKSCH ·
MAZUR · GIORGIO FORESTO · ORESTE WEITMAYER ·
GAAFER MOHAMED ABDELRAHIM · HENRY KELLIHER · RENZULLI ·
OTTO VON HABSBURG · RACHAEL AND JACQUI FEATHER ·
PALOMA · PIERO HELICZER · CHERKOORI PRAVIN ·
PETER SCHAMONI · FAMILIE WINKELMAYER · CARL LASZLO ·
IDA SZIGETHY · KIKI KOGELNIK · OTTO BREICHA ·

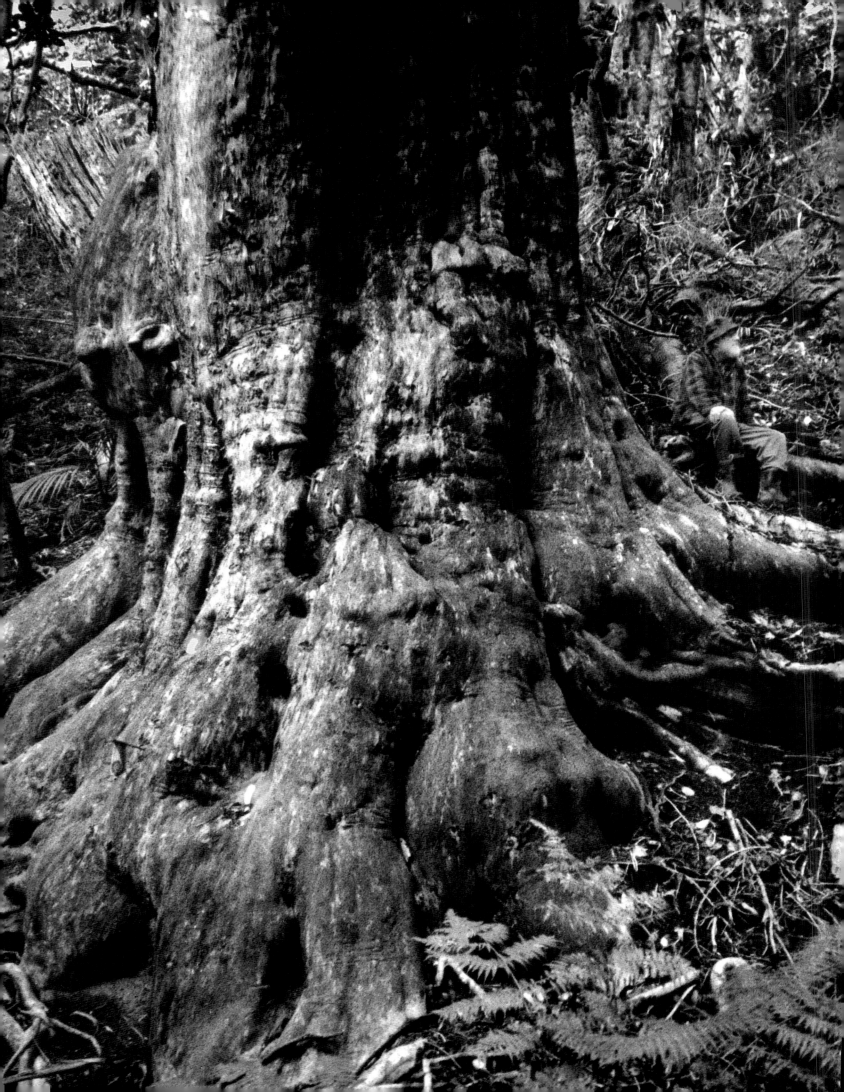

PIERRE RESTANY
THE POWER OF ART

HUNDERTWASSER
THE PAINTER-KING WITH THE 5 SKINS

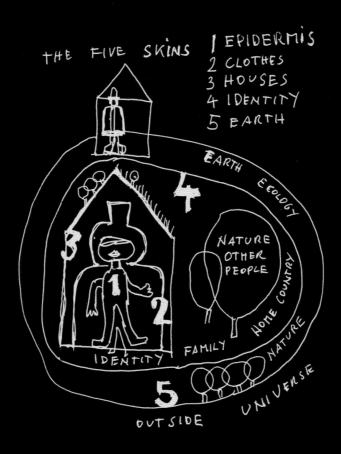

THE FIVE SKINS
1 EPIDERMIS
2 CLOTHES
3 HOUSES
4 IDENTITY
5 EARTH

EARTH ECOLOGY

NATURE
OTHER
PEOPLE

HOME COUNTRY

NATURE

IDENTITY FAMILY

OUTSIDE UNIVERSE

TASCHEN

Pierre Restany was born in 1930, and brought up in Morocco. He later studied in France, Italy and Ireland. In 1963 he worked on the art and architecture journal "Domus", and since 1985 he has edited the magazine "D'ARS". His meeting with Yves Klein in 1955 inspired his 1960 theory of "Nouveau Réalisme" and he founded an art-group of the same name in Paris. He has written and published extensively on the art of the twentieth century. He currently lives and works in Paris and Milan.

We wish to thank the following photographers and institutions:

Wayne Andrews/Esto, p. 24 top right; Wonge Bergmann, p. 52 bottom; Gabriela Brandenstein, p. 18 bottom; Peter Dressler, p. 49 top; Josef Maria Fallnhauser, p. 91; Franz Hruby, p. 55; Helmut Klein, p. 51 centre; Johann Klinger, p. 30; Hubert Kluger, p. 42, 45, 46, 48 top, 49 bottom, 54, 86; Pedro Kramreiter, p. 41; Christa Kreuter, p. 53 top, 54; Gunshiro Matsumoto, p. 53 bottom; Mlynarcik, p. 4; Stefan Moses, p. 14, 17, 39; Herbert Prasch, p. 67 top; Martha Rocher, p. 22; Ernst Schauer (District Heating Plant, Vienna), p. 48 bottom; Alfred Schmid, p. 2, 76 top; Heinrich Schwienbacher, p. 50; Shunk-Kender, p. 38 bottom; Hans Wiesenhofer, p. 50, 51 top; F. A. Brockhaus AG, Mannheim, p. 89 bottom; Citizen Tokyo, p. 56; Pattloch Verlag, Augsburg, p. 89 top; Wolfgang Seidel, p. 50 and Heinz Springmann, p. 57; University Hospital, Graz, p. 52 top.

Project editor: Simone Philippi, Cologne
Editor: Ute Kieseyer, Cologne
English translation: Rodney Stringer
Production: Horst Neuzner, Cologne

Front cover: Gottfried Helnwein, *Portrait of Hundertwasser*, Watercolour, 40 x 50 cm, 1983
Back cover: Gerhard Haderer, *Caricature of Tafelwasser* (table water), Acrylic on card, 25 x 29 cm, 1988
Illustration page 2: Giant puriri tree in Kaurinui Valley, New Zealand
Illustration page 3: Hundertwasser, *The Five Skins of Man*, Ink drawing, 29.7 x 20.9 cm, Vienna, 1998

ISBN 3-8228-7641-0
Printed in Germany
GB

CONTENTS

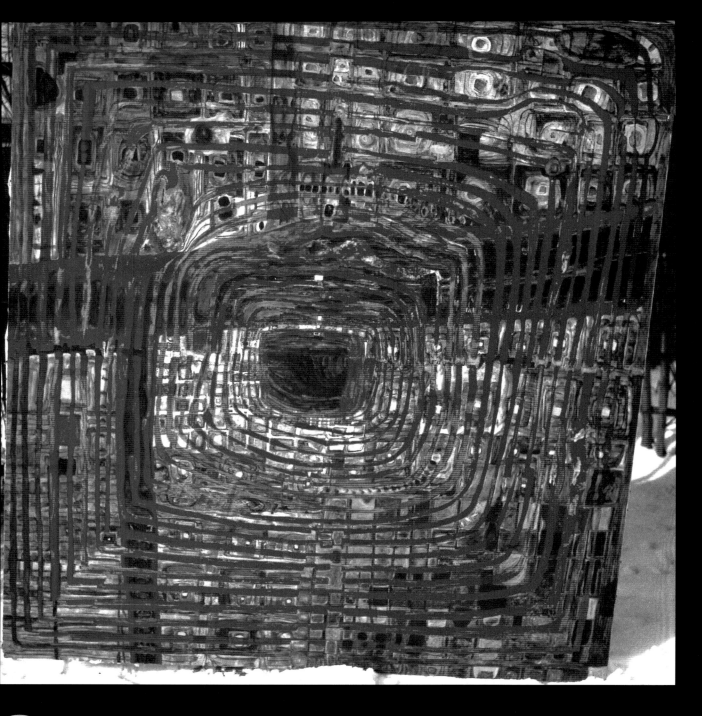

241 *City Seen from Beyond the Sun*, Mixed media, 150 x 135 cm, Saint-Maurice (Seine), 1955

Art has always been a witness to its time. The art of our century has lived through two world wars and a change in the planetary production system. It has attended the collapse of two totalitarian ideologies that have acquainted it with the openings and limits, prospects and contradictions of a world steadily accelerating in the orbit of global culture.

The Marxist ideology has turned out to be the most mystifying, in the image of the immense hope that it had kindled among all strata of people on the left, the universal proletariat fully alerted to its class consciousness. Art placed itself at the service of the revolution, until the revolution took it over to the advantage of its strategy of cultural totalitarianism, for the exclusive benefit of the cause. Whilst the constructivists and surrealists rallied to Stalinism and Trotskyism, Socialist Realism, the official style of international communism, rejoined the ideal of healthy beauty borrowed by Nazi-Fascism from the Italian Novecento movement.

Totalitarian thinking went too often hand in hand with global culture, following the same analogical parallelism as that of today's worldwide economy and information. Our epoch has been marked most of all by two global existential systems; and clearly I refer to Gropius and Le Corbusier, whose structured visions have one point in common: the rehabilitation of the rationalist postulate from a functional angle.

In relation to that globalizing functionalism, certain strong individualities have fully assumed their original vision of being and of society, during the transition from modernity to post-modernity, from industrial to post-industrial society. These uncommon personalities, allergic to the conformity of their surroundings, have delineated the fascinating profile of "the other side of art" in the 20th century. In a history parallel to that of classical art, perfectly indifferent to the traditional dialectic succession of dominant styles, they have produced a constellation of utopian projects sparked by fundamental intuitions. Those visionary utopias have the appearance of a truth progressively revealed by the inexorable logic of an exemplary humanist fate. The free empiricism of their intuitive thinking attacks the conformity pursued by the champions of global culture, and these utopian messages have been looked upon as provocative, not to say subversive.

That dualism between two histories of art has been the outstanding feature of our century. It all began with the first ready-made by Marcel Duchamp, whose masterly reversal of the relation between art and industry put the ball in the public's court: "It is the spectators who make art". Duchamp's message was picked up by the American composer John Cage and his disciples (Robert Rauschenberg, Allan Kaprow, Nam June Paik). It also found an alchemical and sublimating projection in the work of Yves Klein, and a phenomenological connotation in that of Joseph Beuys; whilst it should not be forgotten that the Duchamp-Cage perspective had also been set, and in good time, by Kurt Schwitters and Eric Satie.

Gathered on the other side of art are creators inspired by multifarious idioms that convey the transversality of messages launched by contemporary art, and their growing involvement in the existential pace of daily life. Hundertwasser naturally finds his place there, and a unique place it is, sometimes apparently paradoxical in its unexpected implications. But it perfectly matches the inner logic of his humanist vision, with its ingenuous generosity and practical instinct. This painter in love with beauty spends the best part of his time working as archi-

tecture's doctor, preaching ecological temperance and detesting the straight line as much as he detests the European Union.

Hundertwasser was born in Vienna on 15 December 1928. Today he is certainly the best-known artist in Austria. He is also the most controversial and notorious. His international reputation was already firmly established by the late 1960s, after a hectic career that had begun with a long and decisive stay in Paris, followed by a constant stream of exhibitions, lecture-manifestos and performance-happenings. His fame was then permanently consolidated by a world tour of his works through museums in the five continents, a planetary event guided, between 1975 and 1983, by the masterly touch of his impresario-manager Joram Harel: "Austria shows Hundertwasser to the continents".

His friendship with Joram Harel began in 1972 and relieved Hundertwasser of all material constraints. It enabled him to live according to his most cherished desire: in constant harmony with nature; and to act, at every moment of his daily existence, in complete accord with his principles. In 1972 the death of his mother, to whom he was deeply attached, also came as a major turning-point ("die kehrtwendung", as was to be the title of an address delivered by the artist twice in 1979, in Vienna and at Pfäffikon in Switzerland). His art grew more and more closely identified with the fundamental options of his vision of the world.

In 1968 Hundertwasser bought, in Sicily, an old wooden sailing-boat named "San Giuseppe T", which he brought up to Venice, rebuilt and re-christened "Regentag". From 1968 to 1972 the boat lay moored in the Venice lagoon, where she received innumerable visits from Hundertwasser, who came as much to live and work on board as to sail her along the Adriatic coast. The film-maker Peter Schamoni joined the artist there and together they shot "Regentag" (rainy day), a film that was shown at Cannes in 1972.

In 1972 Hundertwasser published his manifesto "Your Window Right – Your Tree Duty", and also made a spectacular appearance on television in favour of a better-quality habitat: calling for roofs covered with vegetation, and for the individual design of façades. His programme illustrated the resumption of a militant ideological activity, following the pause for meditation and existential recycling spent on board the Regentag. After his "Mould Manifesto Against Rationalism in Architecture" in 1958, in which he set out his fundamental attitude to the sociology of the habitat, ten years went by before Hundertwasser was to sharpen and clarify his naturist position, culminating in his "Naked Speech" and the "Los von Loos" (Away from Loos) manifesto. "The Window Right" thus completed Hundertwasser's system of practical moral philosophy: mould being the metaphor for the creative power of nature. This forceful image was crystallised in successive structural concepts. Man, if he wishes to stay in harmony with nature, must attain to an awareness of his innate right: the individual right to appoint the front of his house in whatever way he likes. "Ornament is a crime", declared Adolf Loos in Vienna in 1908, in reaction to the floral excesses of Jugendstil; and rationalist architecture adopted his message as its credo. Hundertwasser wanted instead to reassure inhabitants and arouse in them a desire to claim their window rights by openly siding with the decorative quality of architecture – an option which he was to conclude in his address of 1981 at Zell am See, on the subject of colour in architecture.

The window right sparked a whole string of impressive gestures that completed Hundertwasser's version of the recipe for happiness on earth: "Inquilino Albero" (Milan, 1973); "Humus Toilets" (Munich, 1975); "The Sacred Shit Manifesto" (Pfäffikon, 1979). After having re-established the cycle of living matter and specified the process of harmony with nature in the key points of his ideological plan, art, architecture and the environment, Hundertwasser went to war against pollution in all its forms: contaminated air, nuclear peril, attacks on nature, destruction of the earth's heritage.

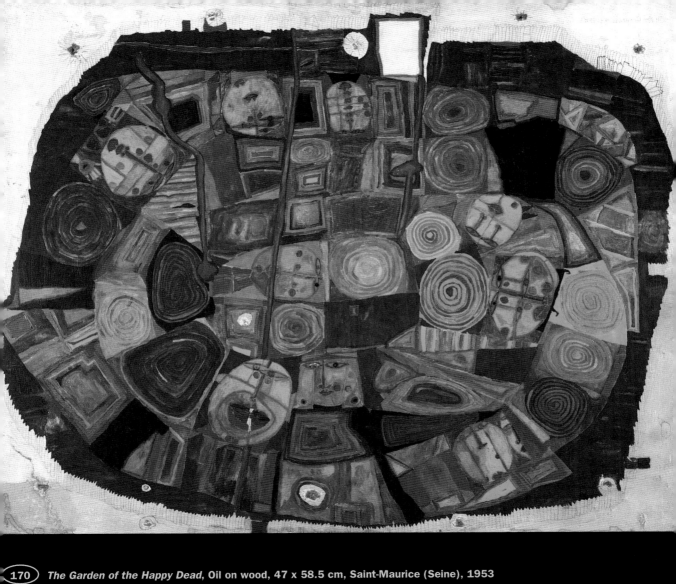

170 *The Garden of the Happy Dead*, Oil on wood, 47 x 58.5 cm, Saint-Maurice (Seine), 1953

A prophetical concept of an ecological burial where the dead survive in the trees planted on top of their graves.

The widening of his social programme was on the scale of the new advance in Hundertwasser's existential pace. In 1973 he discovered New Zealand, during a travelling exhibition of his works that had been shown in the principal cities of that country before going on to Australia in 1974. In 1973 Hundertwasser also inaugurated his first album of Japanese lithographs, "Nana hyaku mizu", and was the first European to have his works engraved by Japanese masters.

In 1976 he embarked in Tahiti on the Regentag, which was waiting for him there. His destination was New Zealand, which eventually became his second home-country. From then on he spent an average of six months there each year, at Kaurinui Valley on North Island, near Kawakawa.

In 1977 Hundertwasser left New Zealand for the Amazon, where he travelled up the Rio Negro, one year before I did. In 1978 he was back in Venice, where he conceived "The Flag for Peace in the Middle East". After that he went to Senegal, as a guest of President Senghor, and did a set of stamps for the Senegalese Post Office. These engagements however did not prevent him from working on a series of new paintings for a travelling exhibition departing from New York (Aberbach Gallery), titled "Hundertwasser Is Painting".

In 1980 the Mayor of Washington, Marion Barry Jr, proclaimed 18 November Hundertwasser Day. The artist officially planted the first twelve trees of the one hundred planned for Judiciary Square. He presented the Mayor with his first example of the poster "Plant Trees – Avert Nuclear Peril" (ill. p. 83), done in support of Ralph Nader's ecological campaign. He also delivered several speeches, including one before the United States Senate, in favour of ecology, against nuclear energy and for an architecture more respectful to nature and humankind. The structural pattern of what later became the operational rite of Hundertwasser's opinion campaigns was also put in place: a striking symbolic act, a series of committed speeches, and a graphic creation to illustrate the theme (poster; postage stamps). His contribution to the campaign for New Zealand's "Conservation Week" (ill. p. 80) in 1974 had served him as a bench-test.

Above all 1980 was a signal date in Hundertwasser's career. The Vienna city council presented the model of his future "Hundertwasser House" to be built on the corner of Löwengasse and Kegelgasse. The artist's idealist criticism turned to practical action. He was to become a builder and to assert his vocation as "architecture's doctor".

By this time, to the itinerant exhibitions of his paintings and engravings throughout the world had been added those of his architectural mock-ups. One project succeeded another, campaign followed campaign; lectures, discussions and meetings kept up the permanent polemic in Vienna and deepened the hostility of "rationalist" architects targeted by Hundertwasser, who gave him back plenty in his own coin. Nothing had in effect changed since the militant period of the Mould Manifesto: nothing, except that Hundertwasser was producing an ever more convincing architectural output in the efficiency of its results and in the illustration of its author's compliance to principles. The die-hards redoubled their opposition, the Hundertwasser family grew bigger and developed from one day to the next.

Since painting his first spiral in 1953, in the studio of his friend René Brô, Hundertwasser had sealed his vision of the world and of his relationship with exterior reality. It was a relationship forged by osmosis, starting from successive levels of consciousness, and concentric to his inner self. The pictorial symbol illustrated the biological metaphor. For Hundertwasser, man has three skins: his natural epidermis, his clothes, his house. When in 1967 and 1968 the artist delivered his "Naked" address to proclaim man's right to his third skin (the free alteration of his house), he accomplished the ritual full cycle of his spiral. He re-found his first skin, that of his original truth, his nakedness as a man and painter, by stripping off his second skin (his clothes) to proclaim

the right to his third skin (his home). Later, after 1972, when the major ideological turning-point had been passed, the spiral of Hundertwasser's chief concerns began to unfold. His consciousness of being was enriched by new questions, which called for fresh responses and elicited new commitments. So appeared the new skins that were to be added to the concentric envelopment of the three previous ones. Man's fourth skin is the social environment (of family and nation, via the elective affinities of friendship). The fifth skin is the planetary skin, directly concerned with the fate of the biosphere, the quality of the air we breathe, and the state of the earth's crust that shelters and feeds us.

Hundertwasser's visionary spiral had attained its maximal extent. To pick the essential from the substance of the message that contains it, a method had imposed itself upon me with the evidence of common sense: the successive exploration of each skin, starting from the epidermis, the membranous zone closest to the inner ego, the one that incarnates the nudity of the man and of the painter.

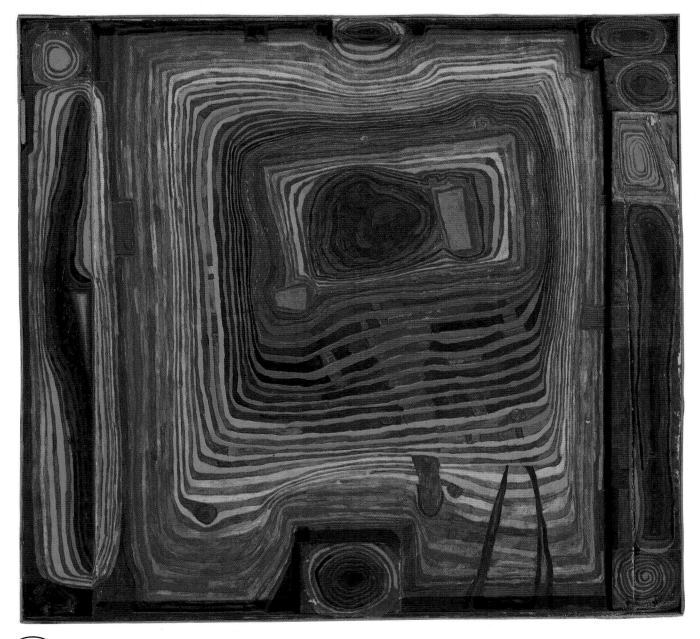

169 *Blood Flowing in a Circle and I Have a Bicycle*, Oil on wood, 51 x 54.5 cm, Saint-Maurice (Seine), 1953

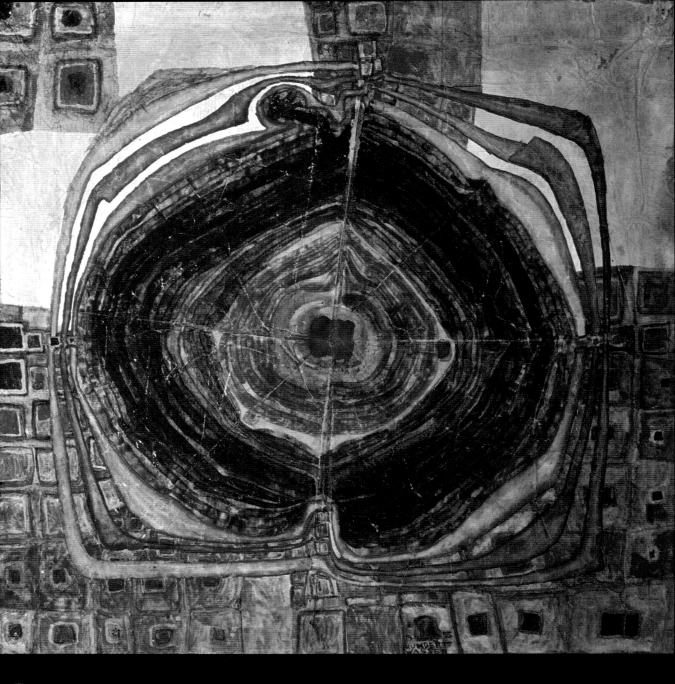

227　*A Raindrop Which Falls into the City*, Watercolour, 42 x 41 cm, Paris, 1955

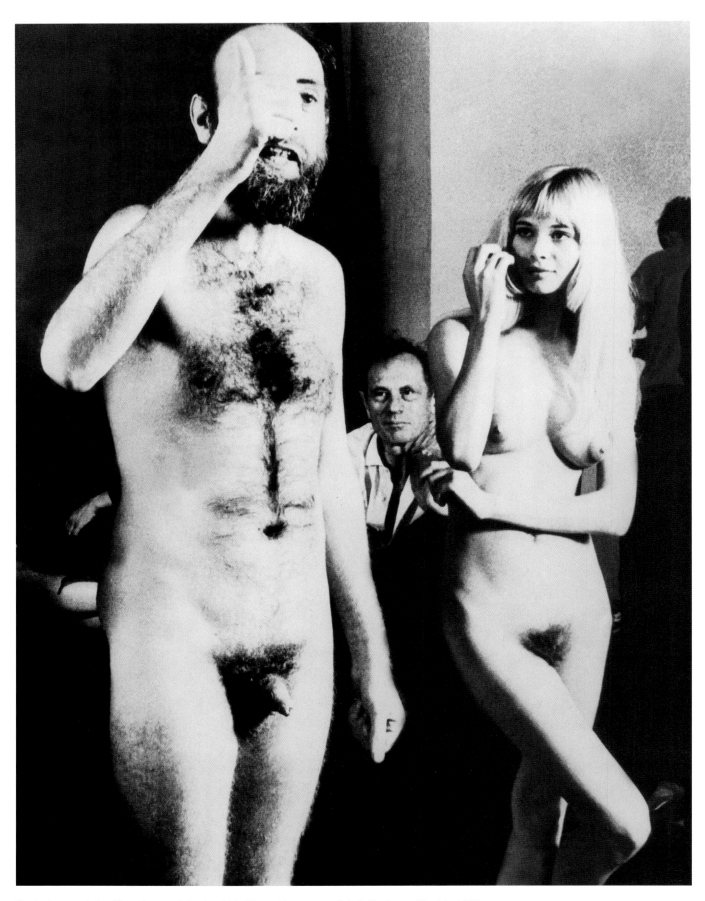

Hundertwasser during his nude speech for the third skin, architecture, at Galerie Hartmann, Munich, 1967

THE FIRST SKIN: THE EPIDERMIS

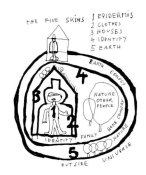

To strip Hundertwasser seems easy at first sight, given the clear evidence of his naturist convictions and the friendliness with which the artist might greet the author of such an enterprise. One quickly realizes however that the loneliness of his childhood has left deep marks. One is not with impunity the only child of a Jewish mother and an Aryan father (who died in 1929, when Hundertwasser was just one year old) – in the tricky period that Austria went through after the Anschluss. His "half-and-half" status saved his life and his mother's too. But the Nazis exterminated all the maternal side of his family. Very soon convinced of the relativity of human affairs, he rapidly surrounded himself with psychological protection barriers that helped him to postpone crucial moments of decision. Much later, architecture's doctor spoke of the "untamed irregularities" and "barriers of beauty" that can delay the race to the limit of growth. When agreeing to put on the first skin of his Viennese childhood again, Hundertwasser admits that he was taciturn and backward in his reactions, because he thought too much and too slowly. "As an only child, I felt responsible to others, I wanted to show them I could think, act and be... better." This side of his character was to bear fruit and to make Hundertwasser first of all a truly great painter, for one very simple reason: when you love flowers and keep them pressed between the pages of a herbal, what do you do when you see them wither? You paint them, if you want to restore their colour. And paint them well, if you are anxious to preserve their brilliance for a long time. A more belated episode was to bear out that precocious inkling of his vocation, of his faith in the ineffable power of art. In 1955 Hundertwasser was in Milan, exhibiting at Carlo Cardazzo's Galleria del Naviglio. A dragonfly settled, in all its resplendent colours, on his work table. It was the loveliest of models! While he was painting it, to the rhythm of his imagination the insect's gorgeous colours were transferred into watercolour. When the work was finished, the dragonfly turned grey and died. In a moving poem, "Libellacquarellula" (ill. p. 20), Hundertwasser described the fascinating passage from the colours of that creature to creation.

Nothing, of course, is so simple when one is an aspiring painter without a sou, arriving in Paris in 1949 and deciding to make a name for oneself on the art scene of the 1950s, with no other asset than the stimulating presence of an inspired and stony-broke painter-friend, Brô (ill. p. 21), and the kind hospitality of the Dumage family at Saint-Mandé. Yet the miracle happened, in the most natural way in the world. As early as 1954 I attended Hundertwasser's first exhibition at Facchetti's, one of the rare with-it avant-garde galleries whose prestige sprang from its total independence from the ruling mafia of the Ecole de Paris and of the kinetic or tachist coteries. The few collectors bold or snobbish enough to frequent places of this sort soon grew accustomed to seeing that gangling figure pacing up and down, with the long face crossed by almond-eyes (hence the nickname "Bei Occhi" that immediately sprang to my mind). The singularity of his apparel, moreover, heightened his aura as a promising talent or budding genius. In that milieu of intellectual marginality, his second skin served him as a social passport.

The vicissitudes of his civil status bore witness in any case to his innate penchant for untamed irregularities that engender the happiness of chance. The patronymic Hundertwasser, which has made him famous all over

the world, is not his real name. He was born Friedrich Stowasser. And it was precisely in 1949 that he took the name Hundertwasser. "Sto" means "one hundred" (Hundert) in Russian and in all the Slav languages. Ten years later he discovered that "Sto" might have originated from the qualifier "Steh" or "Stau": Stauwasser, retained, calm waters. He had thus incorrectly germanised his name...

No matter, Hundertwasser sounded good, and it underlined the attraction exercised by the word "water" in all languages, water to the power of one hundred. In 1961, when he spent the whole year in Japan, he changed his first name to Friederich, then to Friedreich. In 1968, in Venice, where he was very concerned with his boat, he worked out a new amalgam: Friedensreich Hundertwasser Regentag was to be his full name, Hundertwasser between a state of peace and a rainy day: peace and rain, two states of grace. More recently, another name was added to the others: Dunkelbunt (vivid, rather sad colours, as if animated by a faint glow that had risen from his inner self: a reminiscence, perhaps, of the flowers in the herbal of his childhood?).

Hundertwasser is a very curious case of idiopathy, I wrote in 1957 in the pamphlet dedicated by the Kamer gallery to him which also contained the final version of "The Grammar of Seeing". Hundertwasser's illness cannot in effect be related to any other. It is the sickness of an extreme talent, very soon fixed in the formal elements of a language both decorative, expressionist and auto-symbolic. From 1953 the spiral began to appear as the emblematic element of his work. The spiral depicting the introversion of his life (Hundertwasser had been impressed by the emergence of an irregular spiral in the film "Images of Folly" made by Fulchighioni at St Anne's Psychiatric Hospital in Paris) contained the full myth of the labyrinth. And the word labyrinth immediately suggests the idea of a clue, which brings us back to where we started: to the spiral, the anti-straight line par excellence.

Hundertwasser's hatred of the straight line is well known. Since his "Mould Manifesto Against Rationalist Architecture" (Seckau, 4 July 1958, ill. p. 23) and even since his text for the exhibition at Facchetti's in Paris in 1954, where he had declared that the straight line led to the loss of humanity, a slogan had reappeared with the periodicity of a leitmotif in all the artist's theoretic writings: the straight line is atheist and immoral.

His early establishment of a style, allied to an evident taste for the decorative, shut Hundertwasser straight away into the closed world of his mental workshop, into the maze of his introvert vision. On a formal level in fact, Hundertwasser has been Hundertwasser for fifty years by now and, apart from a few innovations or technical improvements, there is no evolution at all to be noted in this fundamentally static oeuvre, based on a perfect imaginative autarchy. The Viennese painter's imperturbable and hieratic, "transautomatic" outlook on the world since he gained an independent consciousness of it, starts from his navel, to travel through its surrounding nature and back to his navel.

This perfect imaginative autonomy, and the continuity of its immediate consequential visual statement, were from the outset the determinant factors of a work essentially ornamental in its immanence. The great majority of the public feel real satisfaction in "recognizing" a work of art – instead of recognizing themselves in it.

And certainly the career of Hundertwasser, a Viennese painter and authentic citizen of the world, might have been still more dazzling had he been content to present his images as pure flamboyant icons, and his labyrinths as aesthetically closed worlds, against the formal sumptuousness of an Austrian baroque tradition with cosmogonic connotations.

But instead, only by dint of manifestos, theoretic stances, spectacular gestures and exemplary actions, Hundertwasser the man has stubbornly insisted on opening our minds to the daedalian workings of his labyrinthine thought, and showing us the way out of the maze.

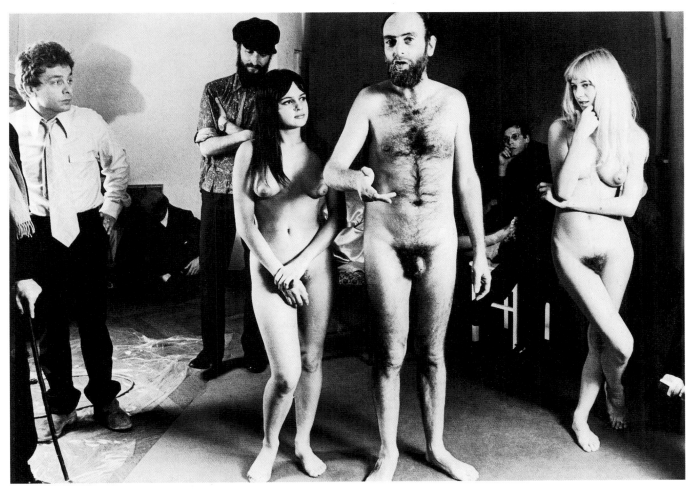

Hundertwasser during his nude speech against rationalism in architecture at Galerie Hartmann, Munich, 1967 (Arnulf Rainer and Ernst Fuchs standing)

These gestures and actions have generally been misinterpreted or misunderstood in the immediate, that is to say at the actual time of their accomplishment. The incomprehension may have in part been justified, for Hundertwasser's "actions" have always been purely intuitive, spontaneous, non-premeditated, motivated by the sense of a truth, always the same: his hatred (symbolized by the straight line and its spiral antithesis) of rationalism in all its domains, and particularly in the one that most directly conditions the individual – the structuring of his habitat and determination of his way of life.

The truth is simple, as is all Hundertwasser's theoretical thinking, and it leads him to impulsive and spontaneous testimony rather than to proselyte demonstrations. His simple truth rests on a universal postulate: that nature is an end unto itself. It has no other cause but itself, nothing exists outside itself. The perfect autarchy of its structure engenders universal harmony, beauty. Art is the path that leads to beauty. The great artist is the true man: he possesses the gift of showing us beauty in the most sublime aspects of its intensity.

Everything would be for the best in the best of worlds if integral naturalism was a doctrine universally admitted by humankind. Beauty, as the expression of the world's harmony, would assure the happiness of all humankind on earth. The mystery of creation would stay intact if all men and women, touched by the grace of beauty, were to become creators. The grace of beauty, the secret of creativity in the innermost depths of the human soul: therein lies the foundation of Hundertwasser's naturalist religiousness. His spiral is Austrian, Jugendstil, Baroque, Roman, Celtic, Coptic, Mesopotamian, Maori... religious: that is why it pulls us so "natu-

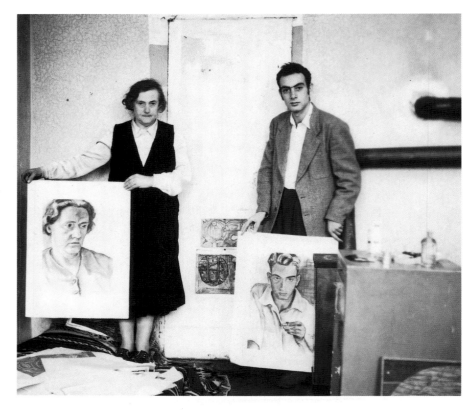

Hundertwasser with his mother, Vienna, Obere Donaustrasse, c. 1955

rally" towards the infinite perspective of the different levels of unconscious that occupy our minds. The alchemy of colours practised by the painter in his minutely detailed work has no other purpose than to make us feel the spirituality of matter.

Art easily adapts to the transcendental virtue of the irrational, but science refuses to do so. It opposes naturalism with rationalism: the universe stems from a number of causes accessible to human reason. Hundertwasser immediately spotted the enemy and practised the amalgam, while projecting its epistemological bias and rational mood onto his architectural doctrine. The supremacy accorded in construction to structure and function, he believes, at the expense of humanizing and decorative treatment, has in the 20th century established the tyranny of the straight line, the mother of all evils, mother of uniformity and ugliness.

"The immoral and impious straight line": it is with a religious fervour that Hundertwasser adopts the naturist option. His naturalism is presented as the moral hygiene of man's presence in the world. The fervour displayed by the artist in his innumerable speeches, performances, stances and opinion campaigns must not create any illusions. It is proof of his perfectionism in the accomplishment of his moral duty. Hundertwasser does not seek to convince, persuaded as he is of the validity of his moral behaviour: his actions speak for themselves, his manifestos likewise. The truism engenders scandal, in Vienna particularly it seems, and Hundertwasser has gained a sulphuric reputation for being the eternal naive beatnik or buffoon playing the mental terrorist. But that has never bothered him. He believes in his star, as

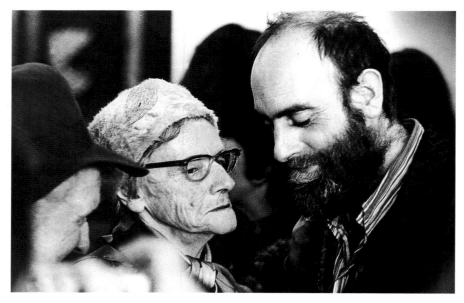

Hundertwasser with his mother shortly before her death, Vienna, 1972

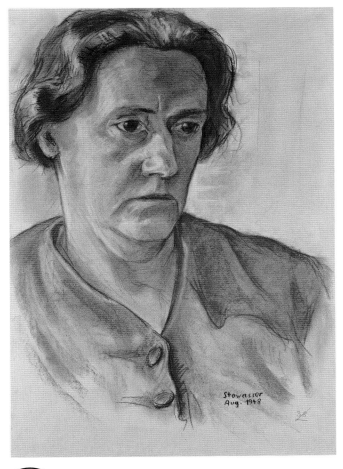

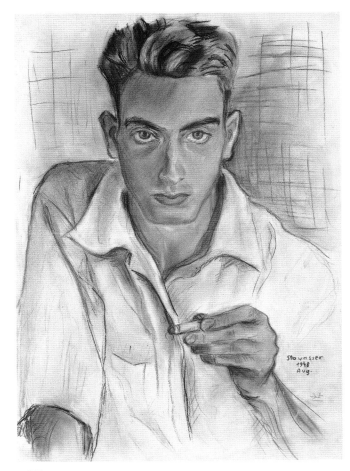

(KK 29) *Portrait of My Mother*, Pastel on paper, 62 x 43 cm, Vienna, 1948 (KK 28) *Self-Portrait*, Pastel on paper, 62 x 43 cm, Vienna, 1948

long as it does not have five points. Time, moreover, is on his side. Many statements deemed cranky, many acts considered irresponsible, have subsequently proved their full value. If one watches the metaphors that nurture Hundertwasser's acts and speech, one notices that they are anticipatory fables endowed with a delayed-action morality: they are veritable "parables". The delayed-action strategy is of capital importance in the artist's expressive path and we shall be seeing later, at the level of his fifth skin, how that strategy has permanently oriented his ecological reflection.

At bottom, Hundertwasser speaks to his epoch as Christ spoke to his, with the aid of parables which to begin with simply expressed pure obvious truths. His close friends are, like the apostles, the first to appreciate their essence. Today Hundertwasser is beginning to harvest the spiritual seed of his "parabolic" teaching. But an immense task remains to be carried out and numerous projects are held in check. The good understanding that he has with his close friends is more and more precious to him: for they are his true family, in the proximity of his fourth skin.

"Hundertwasser stripped bare by his friends even": it is this direct relationship between the fourth and the first skin that enables us to grasp the breadth of the moral-hygiene message delivered by this visionary naturist who, since 1972, has devoted more and more of his best self to the defence and illustration of the human condition, in his practical search for a better life on earth. Hundertwasser offers the most fervent humanist alternative. Against the apocalyptic nightmare of galloping technology, the integral naturist pits his anti-rationalist theory to prove the facts, building in his lifetime what will remain the exemplary sketch for society of

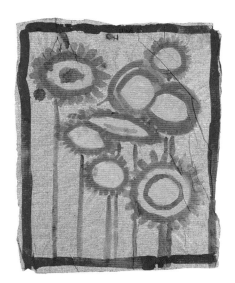

LIBELLACQUERELLULA

Ero seduto in quella casa di vetro
col pennello pronto e sognavo
- come dev'essere sempre al principio
della pittura.
Cadde una libellula.
Una libellula fiorentina.
Era molto fine
con ali
di struttura meravigliosa.
La misi
sulla carta bianca.
Era morta
ma piena di colori straordinari.
Cominciai a dipingere.
Volevo fare una cosa cosí strana
e meravigliosa come la libellula.
Man mano che i miei colori
si moltiplicavano,
disparvero quelli della libellula.
Anzi rubavo i suoi colori
con i quali dipingevo.
I colori piú belli io presi dapprima.
Il quarto giorno
la pittura era finita e bella,
grigia e sminuzzata la libellula.
La libellula si è putrefatta a Firenze.
La pittura, la portai a Vienna.
Poi al Naviglio di Milano.

HUNDERTWASSER

Poem "Libellacquerellula"

well-being based on a harmonious relationship between humankind and nature. What does it matter if Hundertwasser's message at times assumes the extreme air of being an inspired prophecy. As for example, his speech on "False Art and the Pretension to Politico-cultural Power", delivered in Vienna on 14 May 1981, when he received the Austrian National Grand Prize; a speech that brought him a hurt and outraged letter from Wieland Schmied, his biographer and friend. My own personal role, as part of his fourth skin, is to distinguish the wheat from the chaff in these epidermic considerations, and to bring out the real sense of its implied metaphor.

Such is the purpose of this book, which differs, a priori, from most of the abundant bibliography aroused to date by Hundertwasser, the man and his oeuvre. I have made extensive use in this essay, of my privileged relationship with the artist, which has expressed itself with singular intensity in three stages, each separated by an interval of twenty years: 1957, when we drafted the final version of the "Grammar of Seeing" for the pamphlet published by the Kamer Gallery; 1977, on the occasion of the publication of my "Hundertwasser Happy" by Ballantine Books; and 1997, at the time of writing these lines.

Let us go back to the first skin. With Hundertwasser, art and convictions go hand in hand. The painter, the theorist-builder and the social hygienist share the same skin. But the right to first possession falls to the painter. When in 1972 he inaugurated his concrete action on the social fabric (alteration of the façades of houses during the television programme "Make a Wish", ill. p. 30), he was a successful painter with a career reaching back more than twenty years. Twenty years peppered with journeys, and a long initial period of alternation between Vienna and Paris.

Hundertwasser painted his first spiral in 1953 and developed his theory of transautomatism in 1954. Today we realize that those acts, both of which took place in Paris, sealed the artist's relationship with reality and his vision of the world. What was their effect on the art scene of the 1950s?

His theory of transautomatism was at once a criticism of the public's perceptive illiteracy and an affirmation of the necessity for creative involvement by that public in the work of art. The notion of a "transautomatic creative individual film" merely resumed the idea cherished by

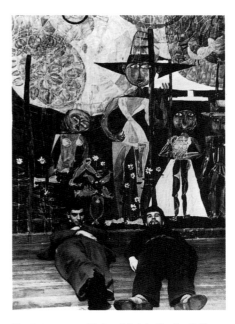

Hundertwasser with René Brô in the Castiglione pavilion at Saint-Mandé near Paris in front of the mural they painted together, 1950

14

HUNDERTWASSER 1954/57 LA GRAMMAIRE DU VOIR (APERÇU)

Grammaire du pré-voir ou la fausse Grammaire, Grammaire associative et comparative, applicable à la perception de tout Art Moderne, jusqu'à l'automatisme seulement. En face d'un t.a.o. (trans automatic object), Cette Grammaire sert comme start au vrai Voir seulement, c'est-à-dire, pour le film individuel créatif transautomatique pour lequel cette Grammaire n'est applicable que comme énergie de départ.

I

Les quatre groupes STATIQUES des associations des sens.

A	Confrontations d'un objet en face duquel on se trouve avec autres objets ou images des sens se trouvant au-dehors du spectateur et existant par eux-mêmes par nature sans l'aide, soit absolue, soit relative du spectateur			OUIE.	FLAIRE	TOUCHER	GOUTER	MUSCLE.	SEXE.			
1	COMPARAISONS SIMULTANEES avec images du genre	OPTIQUE		:	:	:	:	:	:	toutes les COMBINAI-	soit figuratives non-figurat.	PRESENT
2	COMPARAISONS AVEC L'EXPERIENCE (déjà vue) avec images du genre..	OPTIQUE		:	:	:	:	:	:	SONS entre LES SENS..	soit figuratives non-figurat.	PASSE
3	COMPARAISONS AVEC LE POSSIBLE, PROBABLE avec images du genre....	OPTIQUE		:	:	:	:	:	:		soit figuratives non-figurat.	CONDITION- NEL & FUTUR
4	et leurs combinaisons entre les temps (1, 2, 3)											
B	Confrontations d'un objet en face duquel on se trouve avec autres objets ou images des sens se trouvant au-dehors du spectateur comme conséquence de sa propre activité, soit capacité créative, soit absolue ou relative.			OUIE.	FLAIRE	TOUCHER	GOUTER	MUSCLE.	SEXE.			
1	COMPARAISONS SIMULTANEES avec images du genre............	OPTIQUE		:	:	:	:	:	:	toutes les COMBINAI-	soit figuratives non-figurat.	PRESENT
2	COMPARAISONS AVEC L'EXPERIENCE (déjà vue) avec images du genre..	OPTIQUE		:	:	:	:	:	:	SONS entre LES SENS..	soit figuratives non-figurat.	PASSE
3	COMPARAISONS AVEC LE POSSIBLE, PROBABLE avec images du genre....	OPTIQUE		:	:	:	:	:	:	soit figuratives non-figurat.	CONDITION- NEL & FUTUR
4	et leurs combinaisons entre les temps (1, 2, 3)											

First page of "The Grammar of Seeing", Editions H. Kamer, Paris, 1957

Duchamp that it is the spectator who makes the art. It is true that the text on "the visibility of transautomatic creation" was published in Paris at the height of a triumphant tachism, and that the whole revolutionary power of the ready-made aspect of Marcel Duchamp's vision had been quite forgotten at the time. Since then the author of these lines and his New Realist friends have contributed not a little to the propagation of that humanism of visual evidence. The public today are better prepared to assume the responsibility ensuing from their "right to look" in the elaboration of the criteria of taste. If the "Grammar of Seeing" (1957) has lost its interest today as far as aesthetic perception is concerned, it remains more valid than ever as far as social conscience is concerned.

In fact, no sooner had he finished its editing than Hundertwasser sensed the limits of his "Grammar of Seeing", whose system of mental associations and sensorial confrontations can only account for the automatism of the structures of perception in the field of communication in general, and of painting in particular.

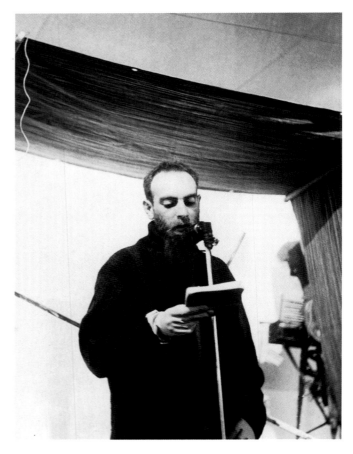

Hundertwasser during the "Stinging Nettles" initiative at the Anti Procès of Alain Jouffrey, Paris, 1960

So begins the path to happiness in beauty, though the real road lies beyond, when the organic and the elementary are re-entered. It is through this passage that the perceptive individual attains to the use of his or her right to creation. (And to define that essential passage from inert matter to the living work of art, I readily borrow the term "transsubstantiation" employed in this connection by the atheist Marcel Duchamp, and which defines the central mystery of the Catholic liturgy.) The right to creation is a universal one, and we can all possess it, provided we deserve it. That is why society is criminal: by the education that it gives us, it arouses reflex-automatisms that cause us to live badly in our second and third skins, by distracting us from our real purpose, which is to live well.

The inexorable extension of transautomatism to architecture occurred one year after publication of the "Grammar of Seeing". On 4 July 1958 at Seckau (Austria, ill. p. 23), during an international art and architecture venue organized by Monsignor Otto Mauer, who at the time incarnated the pivot of Viennese artistic culture, Hundertwasser read his "Mould Manifesto Against Rationalism in Architecture" to a small audience of privileged persons of whom I was one, along with the painter Arnulf Rainer, the critic Michel Tapié, and the curator of the Basle Kunsthalle, Arnold Rüdlinger, and again Walter Koschatzky, Wieland Schmied, and Werner Hofmann.

hundertwasser

verschimmelungs-manifest

gegen den rationalismus

in der architektur

schrift der galerie renate boukes

wiesbaden 1

The "Mould Manifesto Against Rationalism in Architecture" (cover), 1968

The "Mould Manifesto" took up the themes of transautomatism at the level of the individual and collective habitat: the rejection of rationalism, of the straight line and of functional architecture, the affirmation of the general liberty to construct. The manifesto describes the ideal trinity of functions that have to be combined in the person of the constructor, the creator in the image of God: 1) the architect, 2) the mason, 3) the inhabitant. The text introduces the concept of mould, a process of slow proliferation, an extension into the built or unbuilt domain of fluid and spiral activity in painting. The blistered mould, subjected to its organic law of expansion, has to ferment structures and explode the straight line in houses. Each inhabitant must cultivate his or her own domestic mould.

The metaphor of mould, aside from its immediate spectacular effect, was to acquire an extraordinary seminal richness in Hundertwasser's evolutionary thinking. It anticipated all the progressive expansion of the integral naturist theory, the osmotic dimension of relations between man and nature, the moral hygiene of his relationship to the world, his participation in the organic cycle of matter. The metaphor of mould thus becomes the parabolic image of the individual's expansive spiral: the house which man makes to his liking is the extension of the clothes that cover his biological skin.

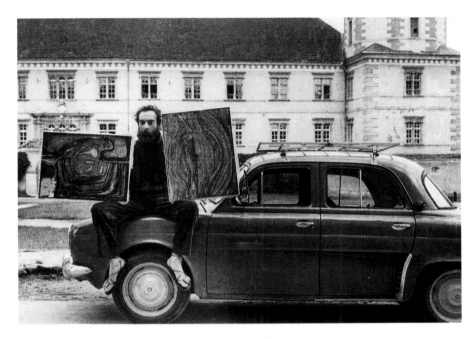

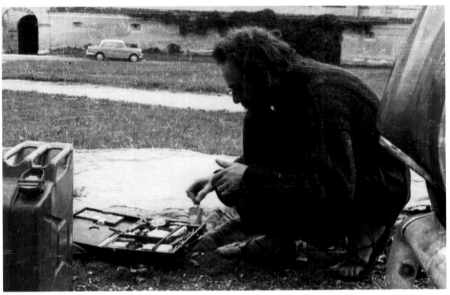

Hundertwasser in front of Seckau monastery, Styria, before reading the "Mould Manifesto", July, 1958

Associated with the drafting of that manifesto, I wanted to go further in its systematization. The last paragraph of the Seckau text, my personal contribution, considers the mass and serial production of domestic mould. Two public readings of the manifesto again took place later in 1958, at the Van de Loo Gallery in Munich and at the Parnass Gallery in Wuppertal. The architect Jährling, director of the Parnass, had even envisaged my request to study a project for a mould factory. The project never got beyond the paper stage.

The "Mould Manifesto" was completed in two stages, in 1959 and 1964. The first addendum involved the list of "healthy" constructions, judged by the author to be exemplary of the present epoch. I quote from memo-

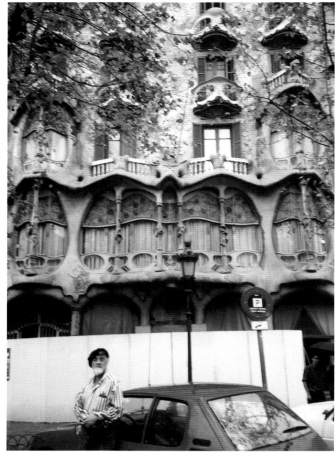

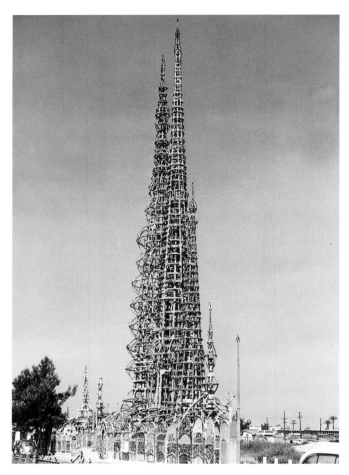

Hundertwasser at Antoni Gaudí's Casa Battló, Barcelona, 1990 **Watts Towers, by Simon Rodilla, Los Angeles, 1921—54**

ry, and to underline "its shameful brevity": Antoni Gaudí in Barcelona (ill. p. 24); Art Nouveau in Vienna; Simon Rodilla's Watts Towers in Los Angeles (ill. p. 24); the postman Ferdinand Cheval's palace at Hauterives in the Drôme department of France (ill. p. 25); the insalubrious districts and depressed areas of all cities (shanty towns, slums, etc); the farms and houses that primitive peoples build with their own hands; the workers' houses and allotments (the Viennese Schrebergärten); the walls of urinals and their inscriptions, and a few works by Christian Hunziker. That was 1959. Hundertwasser would complete today the enumeration with a list of his own projects and achievements since 1980, the year Niki de Saint-Phalle also began her fantastic garden-city of tarots at Capalbio, near Grosseto, on the southeastern tip of Tuscany: a "healthy" work which Hundertwasser admires.

The very brief addendum of 1964 stresses that the architect's work must be subordinate to the desires of the inhabitant, and the latter must reiterate his or her "right of access to the third skin".

The creative effervescence of mould was not long in making its effects felt. The two painters present at Seckau, the fantastic realist Ernst Fuchs and the action tachist Arnulf Rainer, were deeply impressed by Hundertwasser's speech. In Vienna the following year, 1959, they readily agreed to found with him the "Pintorarium" : an ideal universal academy, "halfway between the urinal and the picture-gallery", which would assemble all the trends symbolized by the extreme visionary diversity of its three founders. "The Pintorarium is a homeland for all creative people, with no discrimination whatever towards their art, general orientations or philosophy…" After these general considerations, Hundertwasser immediately announces colour: "My theses are:

mould and its theory. The renewal of architecture by rot. The putrefaction of rational architecture". He appeals to the general mobilisation of the eye and completes the "Grammar of Seeing" with a series of precepts defining the practical moral idea of the first skin: to walk barefoot, to survive free from economic constraint by feeding on corn, and to practise narcissism as a unique form of altruism.

The operational strategy was sharpened and a few months later the artist went into action. Thanks to a recommendation from his friend Siegfried Poppe, one of his first collectors, he was appointed associate professor at the Insti-

"Le Schtroumpf", a residential complex in Geneva designed by Christian Hunziker, completed in 1984

tute of Fine Arts in Hamburg. He took up his post in October 1959 and in vain exhorted his students to leave the school. After three months he found an occupation for them: for two days and two nights they were to paint on the walls of the classroom, the door and windows an endless line, in pencil crayon, ink, oil. "The Hamburg line" (ill. p. 27), traced in December 1959 at the suggestion and with the aid of Harald Schult and Bazon Brock (ill. p. 26), constitutes (scandal and resignation from the post apart) the most representative act of the syn-

Hundertwasser at Facteur Cheval's "Palais Idéal", Hauterives, 1995

thetic tour which Hundertwasser's developments were to undertake at the time: the moral hygiene began to enrich the critical conscience of the first skin. A criticism of teaching, education, the artistic condition, and of architecture, but also a radical and luminous affirmation of the inalienable right to absolute freedom of poetic expression. In the enthusiastic and exalted text which I wrote on that occasion, I did not overlook an objective realisation, namely that "the spiral running round the four walls of a house regenerates its structure, from its foundations to its framework. It is the most efficient of moulds."

In 1960 in Paris, in connection with Alain Jouffroy's anti-process, and on the occasion of his exhibition at Raymond Cordier's, Hundertwasser organized his evening of "Stinging Nettles" (ill. p. 22). He offered 200 people a nettle stock cooked in a laundry boiler: "Do you know that it is easy to live without money? All you have to do is eat nettles … Nettles grow everywhere. They cost nothing … Eat them!" Nobody wanted any, but he sacrificed himself and ate the stuff. The nettles,

alas, turned to hemlock. Some detergent had been left in the Dumages' washer and the artist was taken ill, thus compromising the moral significance of the parable. He was to pay dearly for that manifestation of moral hygiene and of the first skin. The chronic stomach burns caused by the experience lasted a long time. It took him twenty years to recover.

But it takes much more than a physical ordeal to check the calm strength of Hundertwasser's good narcissistic conscience. On 12 December 1967 in Munich, during an action at the Pintorarium, he delivered naked his address on the right to the third skin (ill. p. 14, 17), in which he exhorted the audience to react against the architectural environment, and denounced the idiotic mimetic reflex of the blind consumer of industrial mass products. The first skin was stripped bare in order better to claim its right to the third.

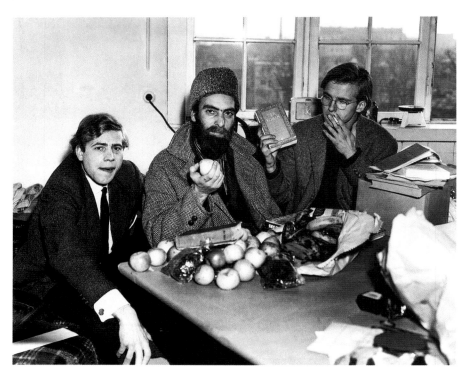

Bazon Brock, Hundertwasser and Harald Schult (from left to right) during the provocative "Hamburg Line" project at the Lerchenfeld Art Institute, Hamburg, 1959

Hundertwasser's hatred of rationalism, coupled with a maniacal individualism, placed Hundertwasser the prophet in a position more and more overtly critical of society. It was again in the nude that in Vienna in 1968 he protested against barren rectilinear architecture (ill. p. 28), by way of a prelude to the reading of his "Los von Loos" manifesto boycotting architecture. The opportunity for that virulent action was given him by the sixtieth anniversary of the publication in 1908 of the architect Adolf Loos' famous book "Ornament and Crime". Hundertwasser's reproach of Loos was precise. The stereotyped ornamentations of the Jugendstil were certainly a lie. They were not a crime. Stripped of all ornament, houses do not thereby grow more sincere. Loos could have replaced the barren ornament with living vegetation. He did not do so. He preached the straight line, uniformity, smoothness. Now, we have the straight line, a diabolical factor in the mortal stress of habitants. In the face of such architecture, there are only two solutions: either to boycott it or to transform it.

Hundertwasser motivated the usage that he intended to make of his right to the individual transformation of the habitat, with the total engagement of his first skin at the time of his previous performance at the Pintorarium during the inauguration of the students' foyer in Vienna. After his naked speech, he had sprayed black paint onto the walls of the "slaves' cage", and red paint onto the ceiling. When drops of red ink dripped back onto him as drops of blood, he could no longer conceal his emotion. Red rain is a frequent image in Hundertwasser's painting (ill. p. 29). Since 20 January 1953 he had made allusions to it in a letter to the Viennese critic Jörg Lampe. The rain of blood is the ineluctable brand of truth, the price which the first skin has to pay for the moral right of free access to the third.

In the "Los von Loos" Manifesto, Hundertwasser reiterated his claim to people's right to exercise their habitual creativity in their habitat: "It is very difficult. One is exposed to everything when one has nothing on. But the triumph is great... It would be a good thing if our government were courageous enough to address the public with no clothes on. It is good to do one's duty. I feel very well."

The four years that followed were related to the Regentag (ill. p. 65) and existential fluidity. Hundertwasser lived and worked on his boat, on the water. The year 1972 was that of his new mooring. And it was marked by two decisive events in his life. One was his meeting, through the good offices of Arik Brauer, a surrealist visionary and popular singer, with Joram Harel, who was to become his agent and confidant and who relieved him of all material problems.

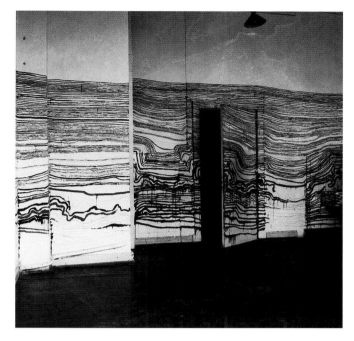

"The Hamburg Line" goes even across the door, Lerchenfeld Art Institute, Hamburg, 1959

The other was the death of Elsa Stowasser, his mother, who was to leave in Hundertwasser's heart a bottomless void which no woman (and God knows how many there have been in Hundertwasser's sentimental career) has ever succeeded in filling.

At the moment in which an existential chapter closed, Hundertwasser's naturist theory was enriched with a supplementary facet that proved immediately operative. In the manifesto "Your Window Right – Your Tree Duty", which he published in 1972, Hundertwasser directly addressed the "creative" man and woman: "It is your right to fashion to your own taste, as far as your arm can reach, your window or exterior façade." The painter turned theorist: the window right is exercised in the exact limit of the physical compass of the gesture of the artist holding his brush. Corresponding to the window right was the tree duty: "Free nature must thrive wherever snow and rain fall. Wherever everything is white in winter must be green in summer. What is parallel to the sky belongs to nature – the streets and rooftops must be wooded – in cities or towns one must again be able to breathe the air of the forest." (ill. p. 31) This fine pictorial vision of the naturist habitat culminated in a burst of spiritual fervour: "The man-tree relationship must take on its religious dimensions."

This access to spirituality must not hide the rigorous logical sequence developed in Hundertwasser's thought. The recourse to mould in the Seckau mani-

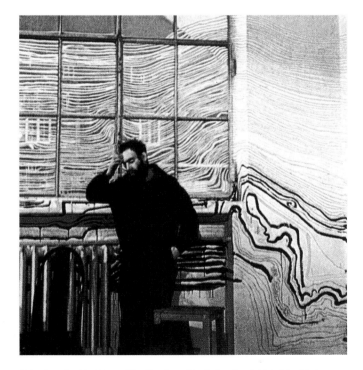

"The Growing Red Sea – The Hamburg Line", Lerchenfeld Art Institute, Hamburg on April 1, 1959

festo logically issues onto the manifesto "Your Window Right – Your Tree Duty" of October 1972. Mould, the active principle of vital fermentation, calls for and prefigures the planting of trees in houses: vegetation through the window, as a factor of hygiene and health, the anti-pollutant par excellence, but also as a factor involving the inhabitant. Hundertwasser illustrated this window right during a "telequiz" between Austria, Germany and Switzerland in 1972. Three families chosen in Vienna, Bülach (Switzerland) and Essen were brought together in Düsseldorf and isolated with no radio or newspapers for a whole day. During that time Hundertwasser embarked upon a record race against the clock, which consisted of the successive alteration of the façades and windows of the three corresponding houses. A veritable marathon by air, it started at dawn in Vienna, continued during the morning in Switzerland and ended in the afternoon in Germany. The alteration concerned the actual framework of the windows and was carried out by a team of bricklayers working under the orders of Hundertwasser and in the glare of the telecamera. That same evening the film of the three actions was presented to the three families, who could not believe their eyes: "We do not have the right to change the windows of our houses – nobody has the right and if you have claimed it, it is because you are an artist and you have every right." By transferring the operation onto the artistic level, the inhabitants concerned felt reassured. They had somehow culturally "disguised" their window rights.

At the Milan Triennale in 1973, for which the commissioner was Giulio Macchi, Hundertwasser took a step forward in the exercise of duty to trees (ill. p. 32). He planted twelve tree tenants on the windows of one of

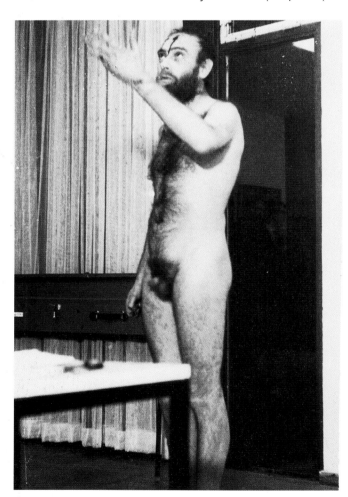

Second nude demonstration against rationalism in architecture at the International Student Hostel, Vienna, 1968

the noblest façades of via Manzoni and brought traffic to a halt during the nocturnal action. Where concrete and tarmac prevent water from infiltrating, the tree tenants helped to balance the situation by introducing foliage to the floors of a building. They purified the air and water, and thus paid for their rent. The idea is a captivating one and enchanted Hundertwasser. He was to take it up again later at intervals in Germany and in Austria and he perfected its technique in every smallest detail. One finds the usage again combined with the tree duty and window rights, in his first architectural hygiene projects. The façades of the Rosenthal factory at Selb and of the Rupertinum in Salzburg received this double treatment: architecture's doctor grew trees through the windows, and embellished their exterior ledges with "tongue-beards" of coloured ceramic.

What had marked the painter's vision in the development of his theory soon came back to painting. From 1973 the tree tenants left their balconies to burst into Hundertwasser's paintings (ill. p. 34). The canvas titled "Tree Tenants Do Not Sleep – Tree Tenants Wide Awake" is dated 1973 (ill. p. 35).

By now his annual stay in New Zealand was part of

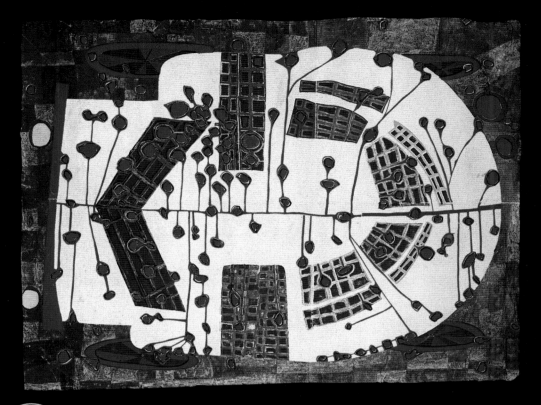

154 *Car with Red Raindrops (II)*, Watercolour, 65 x 85 cm, Vienna, 1957

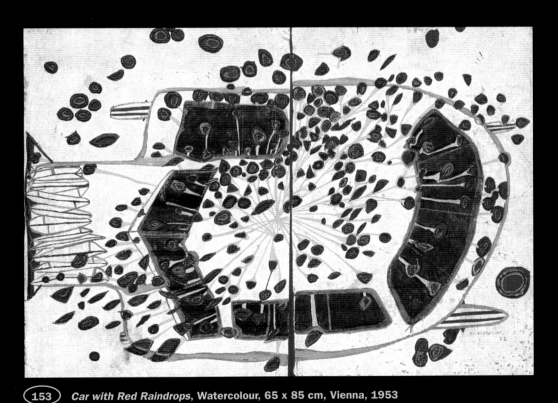

153 *Car with Red Raindrops*, Watercolour, 65 x 85 cm, Vienna, 1953

The first raindrops are a perfect lesson on the harmony and laws of nature which tachism can never equal.

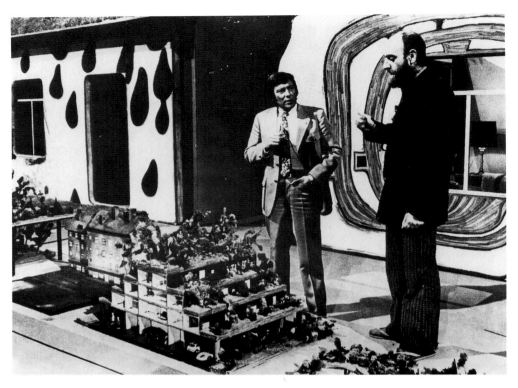

Hundertwasser in the TV broadcast "Make a Wish", with Dietmar Schönherr, 1972

the artist's nomadic wanderings. The different parts of his oeuvre (early works, paintings, etchings) followed the same wandering course and were shown in the four corners of the world. It was at the speed of his European visits that Hundertwasser was to enrich the theoretic structure of his first skin of operative supplementary facets.

Hundertwasser's theoretic thinking is striking for the logical evidence of its empirical progression. His reflection on mould inevitably issued into the conclusion of the biological cycle of nature. With the humus toilets (Munich, 1975, ill. p. 79) and the manifesto "The Sacred Shit" (Pfäffikon, 1979), he took a bold step. "Shit turns into earth which is put on the roof – it becomes lawn, forest, garden, – shit becomes gold … The circle is closed, there is no more waste" (1975). Integral naturistic hygiene has led Hundertwasser to the revelation of the alchemy of matter. He has become a specialist in humus toilets, which he prefers primitive. But the most highly perfected Scandinavian models have no secrets for him, either. In a healthy house, humus toilets are integrated into the organic cycle of the tree tenants and grass roofs. The ideal system tends to autarchy, that of the nitrogen cycle. In the "Sacred Shit" manifesto Hundertwasser went further. He wanted to re-establish the artificially interrupted cycle of shit to food. To reverse the cycle called natural was to attribute to it the spiritual value of the myth of vital energy. Faecal matter thus spiritualised acquires the immaterial power of cosmic energy. It becomes "the way to our resurrection… Shit is our soul". Homo-humus-humanity: the three fateful words mark the destiny of man in his ultimate approach to deep nature. Hundertwasser's conclusion is without appeal: "He who uses a humus toilet does not fear death because our shit makes … our rebirth possible … The scent of humus is the scent of God, the scent of resurrection, the scent of eternal life."

Eternity is the domain of art, Hundertwasser tells us, proclaiming furthermore that art is a kind of life. We have just made a tour of his first skin, which corresponds to the primary, organic and essential level of our planetary consciousness. From mould to sacred shit at the pace of his experience lived and punctuated by perform-

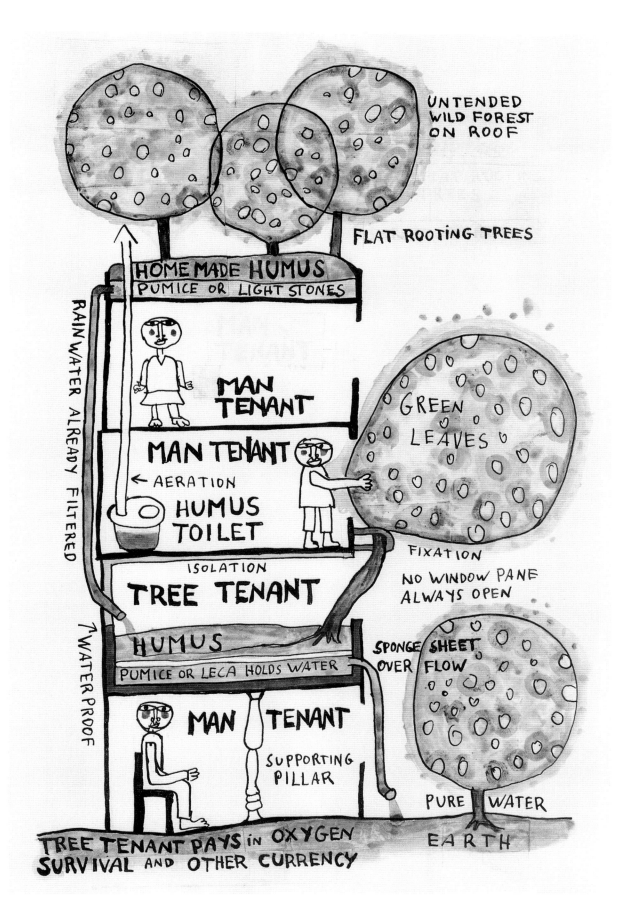

First draft of the tree tenant, Ink with watercolours on white typing paper, 33 x 21 cm, Vienna, 1973

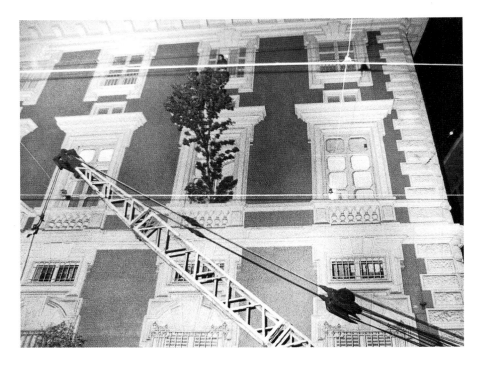

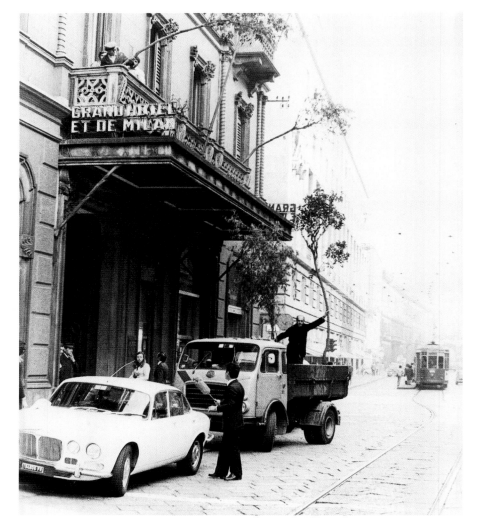

The tree-tenant project on Via Manzoni, Milan Triennial, 1973

ances and manifestos, Hundertwasser's theoretic vision has structured itself around a central equation: nature + beauty = happiness. Man is at the hub of the system: harmony with nature is the key to happiness and beauty is the path leading to it. There can be no beauty without art, which is the art of living. Under the ruthless test of facts, the three fundamental aesthetic concepts are charged with such existential intensity that they swing together in the morals of hygienism, a naturist philosophy of action conducted in search of happiness. Hundertwasser's biological cycle is sublimated in the field of action of moral philosophy. The intuitive theoretician becomes a prophet and settles into the eternity of his vision. Other people's time can only work for him. His certitudes rest on faith in the immaterial power of beauty of people searching for natural harmony. Beauty, and hence all its practical accessories, can only be irrational, in other words anti-rationalist and totally naturist. Shit had turned to gold and Hundertwasser felt good in his first skin. Now it is time to move on to the second level of man-God's conscience.

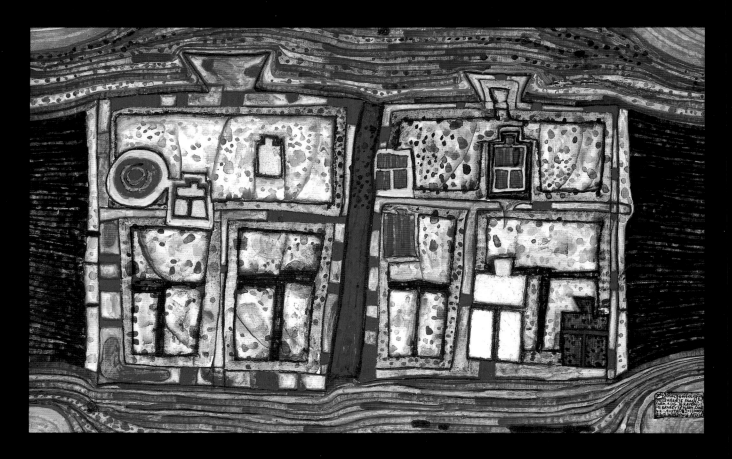

764 *2 to 13 Windows Afloat,* Mixed media, 42 x 65.5 cm, Hahnsäge, 1978

This is a homage to the "Fensterrecht"(windows right), the right of the inhabitant to change his outside walls as far as his arm can reach.

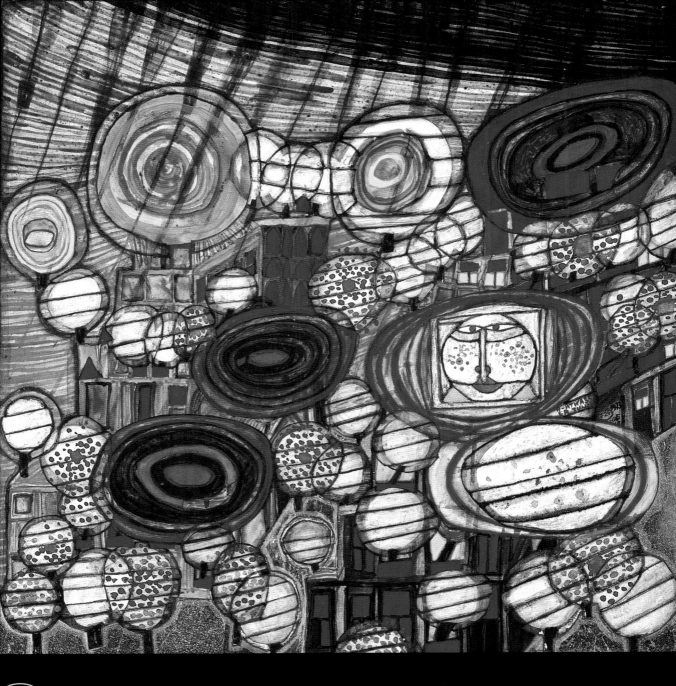

724 *Tree Tenants Do Not Sleep – Tree Tenants Wide Awake,* Mixed media, 38 x 38 cm, Tunis, 1973

Trees growing in and on houses pay their rent without a break in numerous currencies and true values, such as oxygen, silence, as dust swallowers, climate regulators and in beauty.

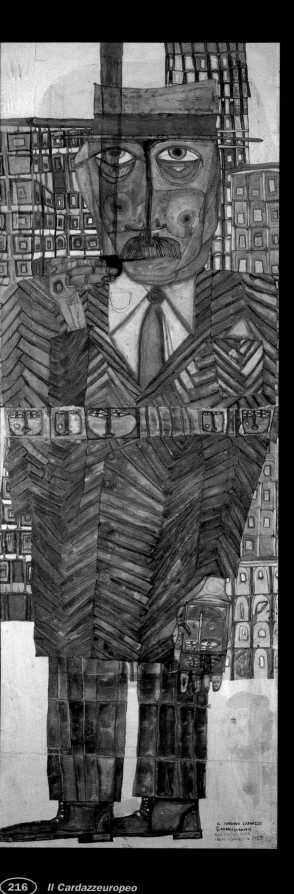

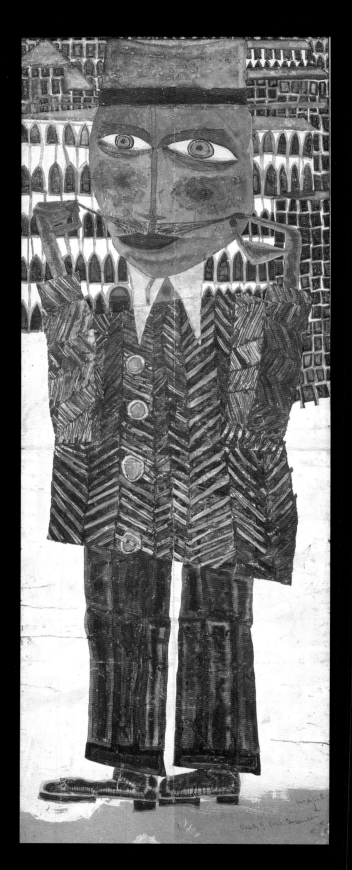

216 *Il Cardazzeuropeo*
Watercolour, 140 x 48 cm, Val
Cavargna, 1955

131 *European Twirling his Moustache*
Watercolour, 128 x 46 cm , Aflenz,
1951

THE SECOND SKIN: THE CLOTHES

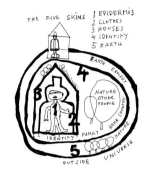

THE FIVE SKINS
1 EPIDERMIS
2 CLOTHES
3 HOUSES
4 IDENTITY
5 EARTH

It was in 1949 that the young student of the Vienna Fine Arts abandoned the academy which he had attended for just three months. He had already made up his mind to go out towards his destiny: a way of saying that he was going to take it on alone. At the end of the long journey that took him from one end of Italy to the other and during which he met the painter René Brô whom he was to follow to Paris, Hundertwasser discovered his second skin, in the existential perspective of "untamed irregularities". He changed his name, from Stowasser to Hundertwasser. Under the influence of Brô, the imaginative freedom of whose dress he admired as proof, in his eyes, of the rightness of an existential commitment, he hung up in the cupboard of oblivion his suit, shirt and tie. From then on he sewed his own clothes out of any oddments of fabric that he happened to come across. He also started making his own socks and shoes (ill. p. 37, 38). A photograph taken in 1950 at Saint-Mandé by Augustin Dumage immortalised his feet, encased in a pair of home-made sandals. Hundertwasser's cap, which was to become as famous as Beuys' felt hat, did not appear until later, when its owner's skull had grown sufficiently bald to accommodate it. This headgear was made from a patchwork of gaily-coloured fabrics fashioned into a rounded cap with a supple peak lowered over the eyes. It might well have been worn by a Chagall peasant or, without looking so far, by a lock-keeper or fisherman, a freshwater sailor who could have been mistaken for an old seadog.

In the 1950s, in Paris, his get-up looked somewhat like that of a mullah, or of a defrocked marabout who had swapped his "saroual" for a pair of pyjama trousers in coarse calico and cut his "djellaba" at the hip to make it into the semblance of a shirt. Add to that a pair of Arab sandals, and one might have expected the singularity of his garb to have caused a scandal (ill. p. 38). But the lounge-leftists of Saint-Germain des Prés had begun to flirt with militant anti-colonialism. So this reminder of North African Third World lore was not going to displease them. For the less committed "aesthetes", the exoticism of his clothes did not have this socio-political connotation: Hundertwasser was a super-bohemian, embodying a return to the wild and woolly attic-painter image. Realizing that his second skin served him as a social passport, the artist began to think about the ratio of clothing to civil status (ill. p. 39).

The cowl makes the monk, they say. But is this

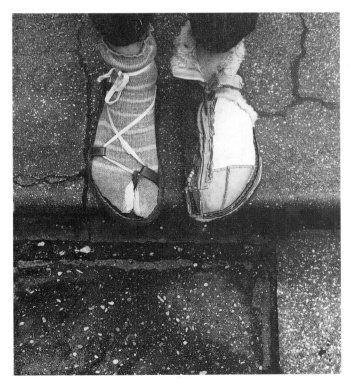

Hundertwasser with self-made summer and winter shoes, with nature-made cracks on the sidewalk, Paris, 1950

still true now that the top executives of leading corporations dress like the humblest of their employees? In a text written in 1982/83, at the time of his show at the Art Curial Gallery in Paris, Hundertwasser denounced the three evils of the second skin: uniformity, the symmetry of ready-made clothes, and the tyranny of fashion. The uniform anonymity of clothing stands for man's renunciation of individualism and of pride in wearing a creative second skin which is original and different from others (ill. p. 41). The infantrymen in the famous painting by Paolo Uccello ("The Battle of San Romano") wear their asymmetrical clothes well. A green hose on the left leg, a red stocking on the right. Hundertwasser always wears a different sock on each foot. At the Kunsthaus shop in Vienna one can even buy exclusive models of his socks. Hundertwasser is fond of striped fabrics for his shirts and trousers, which he never irons. As a result the creases in the crumpled linen soften the optical sensation of the straight line.

Hundertwasser is clever in his creative clothing for personal use, or at any rate he was in the days

Hundertwasser with self-made shoes, photographed with delayed-action shutter release, Vienna, 1950

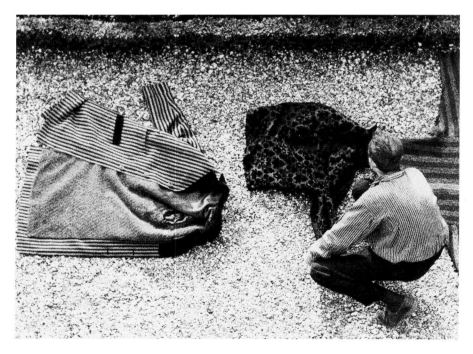

Hundertwasser with self-designed clothes in Saint-Mandé, 1960

when he still had to knock up his own makeshift outfit under the spur of necessity. Today he is a rich man and can afford all the fabrics he likes; his style of dress now expresses a comfortably mild unconventionality. And one should see in this a sign of the times. During the period of the hippies, skinheads or drag queens, the second skin became the distinctive make-up of the fourth: denoting membership of a group that consolidated its "different" identity by adopting a fashion. Since May 1968, otherness had acquired its autonomy of apparel. The slogan "black is beautiful" restored to coloured people their pride in the specificity of their somatic traits. The Afro-American cosmetics industry experienced a prodigious boom. The claims advanced by homosexual

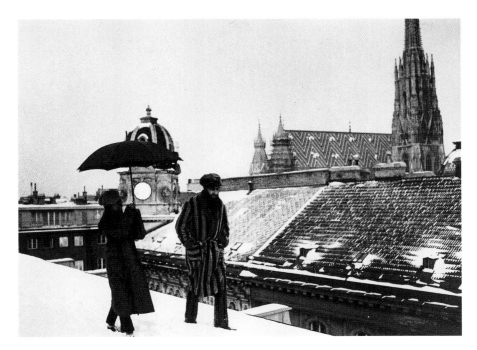

Hundertwasser on the roof of his studio on the Graben, Vienna, 1967

minorities in May 1968 affected clothing, and anti-fashion in design preconized a direct contact with fabric on the skin that created fashion – a fundamental principle that was taken up by fashion designers in the Italian or in the Japanese style. The luxury of clothing lies in its comfort. The right to diversity in the consumer's taste is recognized, it is the approach to normality in difference. Marginality lives well collectively. It won't be long before the inhabitants of Hundertwasser's houses will themselves harmonise their habits with the polychrome shades of their façades or with the colours of the foliage and blossom of their tree tenants. Architecture's doctor will thus have helped them along the path to beauty. They will have created their own anti-fashion fashion! The tyranny of fashion orchestrated by haute couture has become a performed rite of complacent social complicity.

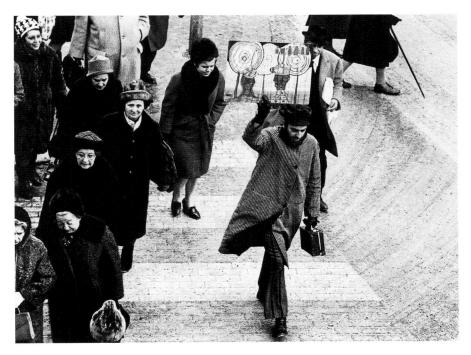

Hundertwasser with self-designed clothes on Stock-im-Eisen-Platz, Vienna, 1967

The scarves, T-shirts, pullovers and "bundle-cloths" (for parcel-presents, inspired by Japanese furoshiki) that make up the Hundertwasser products on sale at the KunsthausWien derive their peculiarity from the flamboyant éclat of their printed images, which reproduce paintings by the artist, often done long ago. The commercial operation behind this "creative clothing" becomes, through the eternal magic of painting, the beauty barrier of the second skin.

On the subject of clothing, one of Hundertwasser's most captivating ideas is the total reversibility of a garment. Take a pair of trousers or a Hundertwasser jacket and turn them inside out. The surface of the fabric is the same on both sides; it has no seam-scars, no gash-hems or patch-linings. This concept of reversibility nicely translates the osmotic nature of the second level of Hundertwasser's conscience. The second skin enter-

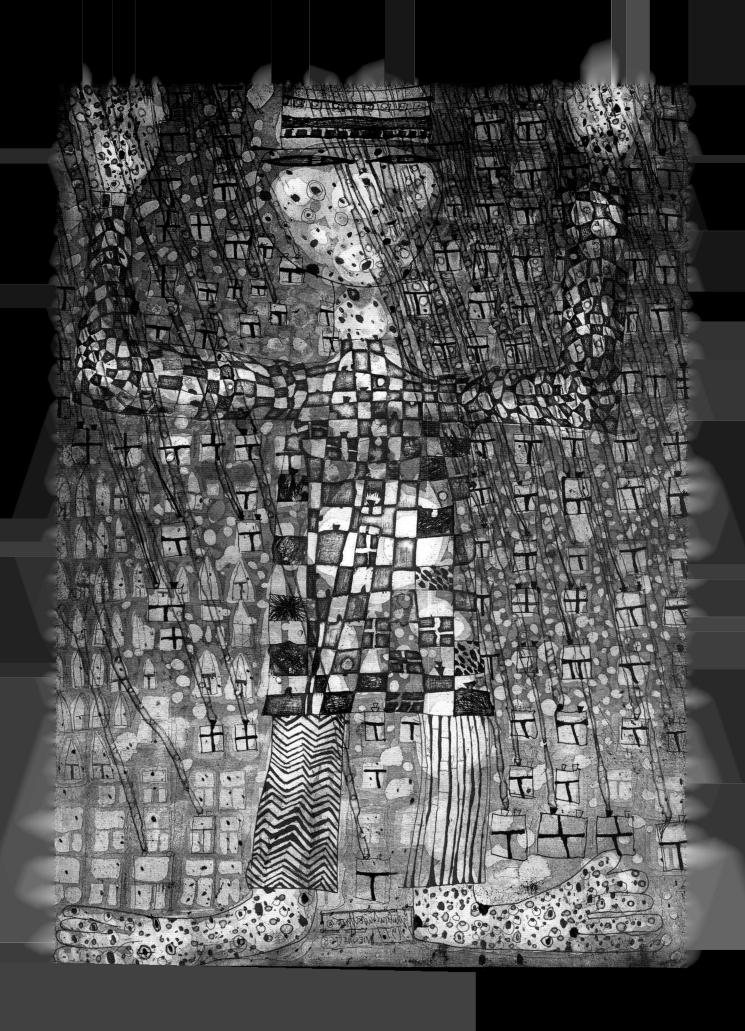

tains a relationship of direct identity with the first, whose civil status it incarnates. But it maintains simultaneously an open approach to the same identity phenomenon of social bodies. An association, a group, a party, an ethnic group or a nation can recognize themselves in certain identity signs, starting from their flags.

The identifying signs of a nation embody the sum and synthesis of all the individual identities of the citizens who make it up. The citizens recognize themselves in these signs, that bear witness to their membership of a nation. The flag acts as the nation's second skin.

Hundertwasser has been highly sensitive to the interconnection between these different levels of consciousness, between the levels of individual and of national consciousness. The right flag is a factor of existential harmony, hence of peace. After 1978 the artist conceived a flag for New Zealand and in 1986 another project for Australia (ill. p. 72, 73).

The second skin opens widely onto the fourth. In this ballet between the concentric mysteries of the spiral of his being, Hundertwasser does not however forget the third skin, the major fixation of his social commitment, man's home.

Hundertwasser in a self-designed, reversible suit for an article in "Vogue", Paris, November, 1982

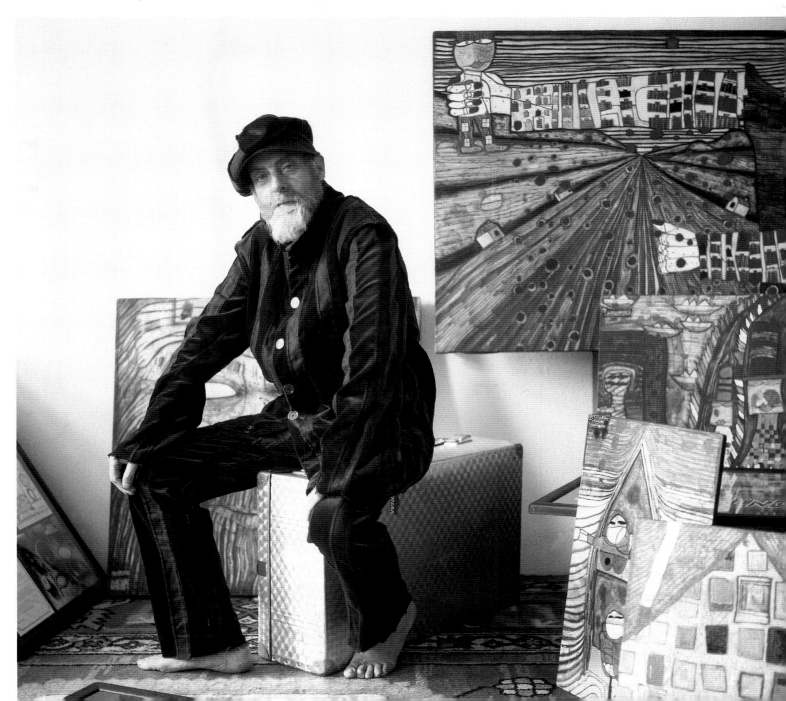

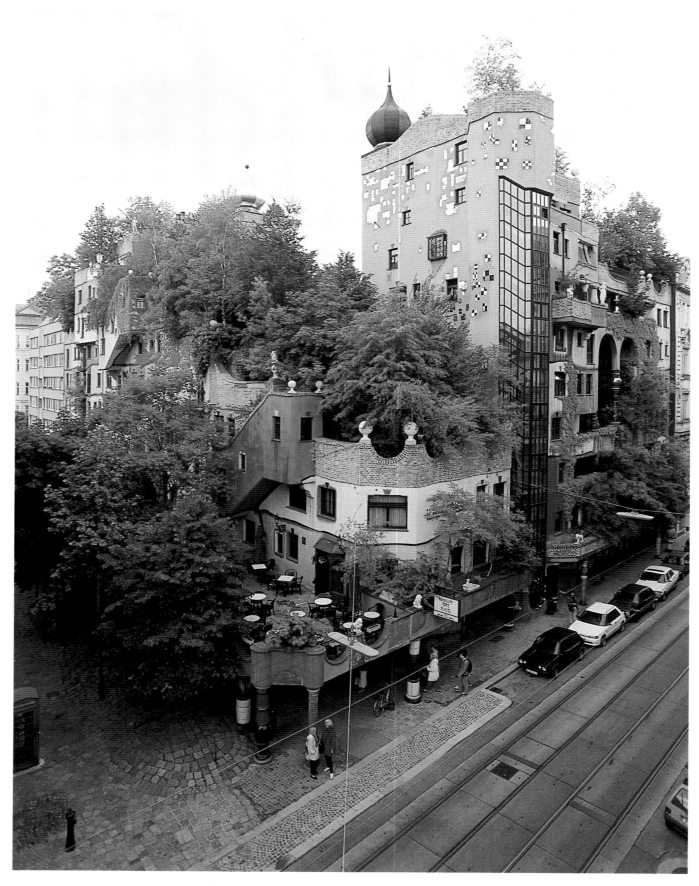

Hundertwasser House, public housing, corner Löwengasse/Kegelgasse, Vienna, 1995

THE THIRD SKIN: MAN'S HOUSE

"L'art pour l'art is an aberration; l'architecture pour l'architecture is a crime." HUNDERTWASSER

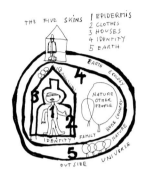

Between 1972 and 1980, Hundertwasser undertook the formative journey of his naturist theory, which had begun in 1958 with the "Mould Manifesto". Intuition succeeded intuition, manifesto followed manifesto. The spiral of conscience reached its point of critical ripeness. The moralist engaged in the offensive of rehabilitating the relation between man and nature, which took over the baton of aesthetic vision from the painter, whilst at the same time wholly assuming it. In that crusade of happiness through beauty, the aesthetic did not swing over into the moral; the aesthetic and the moral went forward together.

My book seeks to study the vision of society proposed by Hundertwasser to men and women today, the means employed by him to achieve his end, and the ensuing precepts of moral hygiene. Numerous works have dealt with Hundertwasser's painting and his fascinating visual magic. Whilst this is not my essential purpose here, I shall not however make any abstraction of it. One realisation comes to the fore: that art is at the core of Hundertwasser's thinking, present in his every least creative breath. The art of painting is his art of living.

As I progress in my analysis of the theory and development of the project at each level of its author's consciousness, his pictorial personality imposes itself by its omnipresence. It is as a painter that Hundertwasser tackles the man–nature issue in general, and it is as a painter that he recommends particular solutions to those problems. From mould to sacred shit, his operative thought is structured in strictly pictorial metaphors.

It is as a painter that Hundertwasser, the nature theorist, tackles the problem of the spirituality of matter in terms of its biological cycle.

It was as a painter that Hundertwasser drafted in December 1981 the text for a speech on colour in architecture, which he was to have delivered at a congress in Zell am See, but never did. "Nature has mainly two colours. The green of vegetation and the black or dark brown of earth and shade … That black goes well with green is of vital importance to architecture." In the painting of houses, he enunciated two essential principles: the supremacy to be accorded to natural colours (earth, clay, brick, lime, charcoal) and to unequal roughcasting in the application of surface facings. And it was as a painter that he expressed his conclusive vow:

Cartoon of Hundertwasser by Dieter Zehentmayr in "Neue Kronen Zeitung", January 16, 1991

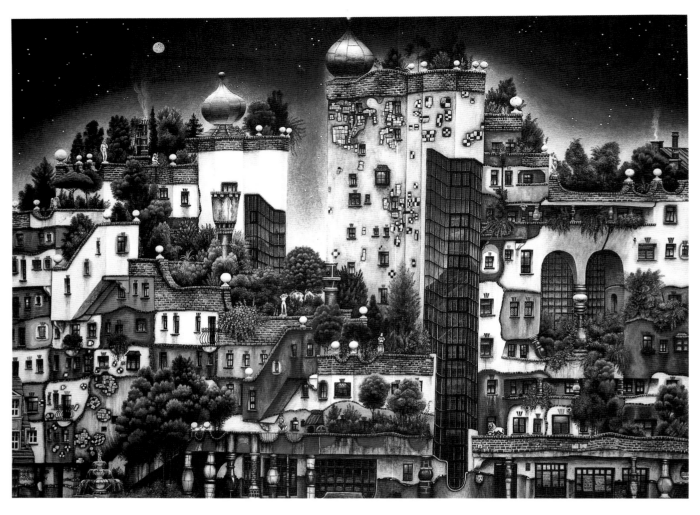

Hundertwasser House in the Moonlight, Colour lithograph based on the original by Karl Goldammer, 47,5 x 64 cm, Vienna 1995

"When we leave nature to repaint walls … they will become human and we shall be able to live again."

The text of 1981 conveys the concerns uppermost in the artist's mind at that time. He was working on the project for Hundertwasser House at Löwengasse, the model of which had been officially presented the previous year by the Vienna City Council, and the first stone of which was laid in 1983. He felt morally ready to take up in its hard facts the permanent defiance of the straight line which he had launched for thirty years in his painting. He also felt that this first project was to be his major opus, that once realised it would acquire an exemplary value, illustrating his entire project for society through the tangible affirmation of his architectural convictions. The moralist of architecture put his philosophy to the test, and the facts proved that the theorist of architecture who had become its doctor, the specialist in the "redesign" of sick houses, was right.

In fact, for these last fifteen years, whilst continuing to pursue his activity as a painter and engraver, and whilst multiplying his ecological campaigns, Hundertwasser had conceived more than 50 projects and models of new constructions, for the rehabilitation of structures and the redesign of façades. A complete exhibition of his architecture is in worldwide circulation. This production is added today to the 700 paintings done to date, and to a graphic oeuvre in excess of one hundred pieces, certain of which have been printed in very large numbers (10002 copies, multiple originals, for "Homo humus – How do you do" – a record!).

An analysis of the Hundertwasser House will be useful as a guide-testimony within this abundant and ever expanding architectural output. It will allow us to clear the structural criteria of Hundertwasser's house and the reactions of its inhabitants, in a word, the morphology and physiology of the third skin.

Hundertwasser House is in effect rich in lessons to be learnt. First of all, it is a commission by the city to the artist. Sensitive as much to his painting as to his theoretical statements, the local councillors offered Hundertwasser the opportunity to realize his utopia. Political power was addressed to Hundertwasser because it was determined to take up a challenge concerning the power of art. The act of constructing à la Hundertwasser was to imprint the hallmark of his creativity on the fragment of urban fabric entrusted to him, on the physical and human scale of the environment. In this precise case, speculation on the power of art assumed the air of a bet on the poetic quality of inhabited space. And since this was a

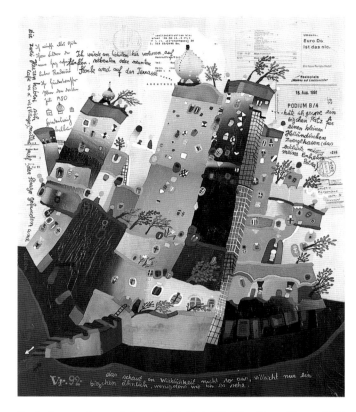

Hundertwasser Corner, **Collage by Vojo Radoičič, 55 x 45 cm, Vienna, 1992**

public housing operation, the political gesture was doubly meaningful. Hundertwasser has proclaimed from every rooftop that man is not at home in his third skin: that something must be done to make him feel well in it, now that the opportunity to act creatively has been given to him. Such is the power of art: by asking Hundertwasser to build the public housing estate on the corner of Löwengasse, the Vienna City Council did not turn to an architect but to a dealer in happiness, passing him an order for a complex of happy spaces.

It is easy to find in Hundertwasser's painting the images that prefigure the structures and details of his houses: irregular alignments of their windows, the spatial integration of trees, the coloured mixture and wavy lines of his urban plans, the onion domes and baroque colonnades. In fact the house is inspired by the collection of themes issuing from the artist's long reflection on the habitat.

The house is presented as a vertical village. Each dwelling is individualized by its own colour and by the exterior treatment of its windows, fitting like a piece in a jigsaw puzzle into the built fabric as a whole. In it

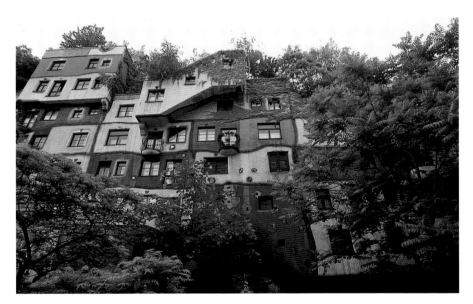

In former times painters painted houses. Today painters have to invent houses and the architects have to build after the painting, because there are no beautiful houses anymore.

one feels truly at home. The main entrance is a colonnaded porch holding up a large vault. A monumental fountain, with a circular brick and jagged-edged ceramic edge sits imposingly at the centre of the space.

The corridors are inner communications animated by an uneven floor and undulating roughcast walls. The coating is renewable and at the disposal of the tags and graffiti of children and adults. Planning extended even to communal facilities: there is a doctor's practice, a winter garden, a laundry, an adventure room with corwex flooring, a children's playroom, a number of public woodland terraces, a café, a restaurant and shops.

The undulations of the skyline remind one of Gaudí's Mila House, as do the curved stairways that lead to the street and form its extension. But the line of the roof on the house in Vienna is embellished by a series of terrace-gardens directly accessible from the flats situated underneath balcony copses for the tree tenants, greenhouses and winter gardens. Outside the windows, the façade is sumptuously decorated with ceramic and silvered metal tiles. Two onion

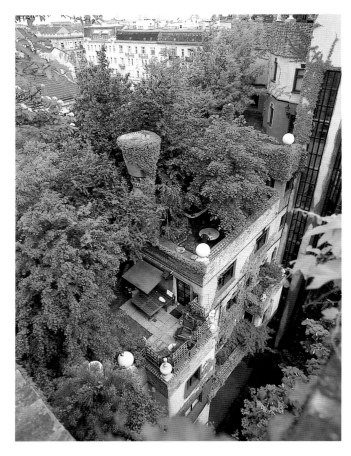

Hundertwasser House seen from above. All roofs under the sky should be restored to nature.

domes, one in copper, the other gilded, like those crowning Austrian Baroque churches, dominate the scene. The convex columns, in sliced polychrome cylinders that make their appearance in the Vienna house, eventually became nothing short of veritable trademarks of the Hundertwasser style, on a par with his tree-roofs, bearded windows, tree tenants or onion domes, and floors humped with broken tiles. The controlled irregularities ran freely in the paving of the kitchens and bathrooms.

The 50 flats in the house fall into 5 groups: 8 having a surface of 40 sq.m, 14 of 60 sq.m, and 25 of 80 sq.m. Two of them reach 117 sq.m, while the largest of them all measures exactly 148.59 sq.m. 37 car parking places are also provided.

On open day, 8 September 1985, the Hundertwasser House was presented to the Viennese public. The success in terms of curiosity aroused was immense: 70,000 visitors queued up to see it. The tenants' favourable reaction has done nothing but increased over the past ten years. In 1991 Hundertwasser transformed the neighbouring Kalke garage into a "village": a meeting-place, café, bookshop and shopping arcade. The inhabitants of the house are conscious of belonging to a group apart. They live differently to, and better than, their neighbours. They are proud to have been able to influence their quality of life themselves. The children among them, moreover, develop harmoniously and without complexes.

At the house the demand for flats is six times higher than the supply (limited only by the regulations in force for public housing: the rich are not admitted): when a tenant leaves, six new applications arrive. Hundertwasser has accomplished the goal which he had publicly set himself at the time of submitting his model in 1980, namely to build "the house of dreams", an oasis for man and nature in a desert of rational housing.

Hundertwasser Haus is a hostage of its own success. It has become the landmark of post-modern Vienna and its inhabitants complain all year long of only one thing: of the invasion by tourists who come flocking there by the busload.

Hundertwasser has drawn a number of human lessons from the house, that have served to corroborate his convictions. Life in the building site was uplifting. The workers realized they were not the slaves of the grid system and of prefabrication. The bricklayers and tilers took individual initiatives that were in their reach, and became creative. The dignity of labour was achieved by the exercise of individual creativity and not by trade-union protests. This realisation was verified as Hundertwasser's career as a builder steadily developed. In the construction sites of major works like that of the health spa village at Blumau, the workers identified themselves with their work. On Sundays they brought their families to show them the results of their labours. "I content myself with giving them a few overall suggestions. No rules, either of set squares or levels. They know they can give free rein to their instinct, and they like me for that", says Hundertwasser. "All those who have worked for me continue to feel a respect and nostalgia towards me."

The necessity to stick to a precise budget situation led Hundertwasser to draw a compromise with prefabrication. To obtain the total diversity of built spaces, he sacrificed the idea of doing every item by hand, making use of a whole range of mass products. The door-locks and handles are all different, chosen from the sales catalogues of various ironmongers. Hundertwasser House has tangibly proved the positive effects of his habitat theory. On this level of technology and of work psychology, it has served as a reference for future works.

And heaven only knows there are plenty of new works! In fifteen years, Hundertwasser has conceived some fifty architectural projects, building half of them. Which is quite prodigious, especially in view of the hostility aroused among the great majority of architects to Hundertwasser's naturist theory and to his built works.

Hundertwasser's works fall into three categories, according to the extent to which they act on the structural site situation.

The term "exterior design" refers to rehabilitating alterations to façades, that come under the direct perspective of the window right and tree duty: the Rosenthal factory at Selb (1980–82), the Rupertinum at Salzburg (1980–85), the Rueff textile works at Muntlix in the Vorarlberg (1982–88) or again, the inner court of the Plochingen am Neckar housing estate, although the complex is a new construction ("Living Beneath the Rain Tower", 1990–94).

Bricklayers for the first time in the limelight of interest: Hundertwasser with bricklayers at the construction site of Hundertwasser House, Vienna. The pride in creative freedom of the workers, who are considered as masters, makes miracles in architecture come true.

The most fabulous monumental achievement in exterior design remains the domestic rubbish incineration and urban heating unit of the Vienna City Council at Spittelau (1988–92, ill. p. 48). Hundertwasser succeeded in converting a thankless, unattractive heap of industrial volumes cluttered with pipes and metal-bearing frames, into a mosque-palace worthy of "A Thousand and One Nights". The cathedral-bazaar of sacred shit, surmounted by a minaret-column barred at mid-height by a luminous onion dome, is the most magical signal at the entry to a large city that can be imagined. The staggering sumptuousness of a legendary Orient announces the Baroque effervescence of the old Viennese tradition. It is thus the work that comes closest to the fairy-tale dear

Spittelau, District Heating Plant, Vienna, 1988–92

to childhood imagination, by presenting itself as the Ali Baba version of a Walt Disney fantasy. Seen from close-up, the building offers a complete sample-range of Hundertwasser's repertoire: garden terraces, roof forests, multicoloured façades, bearded windows and a proliferation of convex columns. The top corners of the different

structural volumes, stressed by the ultramarine columns rising from the ground of a single tenant, are crowned with gilded balls. Their timely statement creates chords in an optical symphony with the minaret-chimney, its onion dome and terminal ring. The onion globe measuring 20.24 m x 17.8 m, in gilded enamel and lit by optical fibres on 1100 sq.m, shines brightly at a height of 100 m, sending out into the Vienna sky its message of happiness in beauty.

There again the commission came from the city. Its mayors may change, but the municipal determination to link Hundertwasser's creative genius with the living structure of the urban fabric stays on, and its tangible proof is there to be seen. Hundertwasser's naturist baroque utopia has become deeply inscribed in the architectural profile of post-modern Vienna.

Faithful to his naturist principles, Hundertwasser made sure that the purification of toxic gases at the power plant was conducted on a par with

Spittelau, District Heating Plant, Vienna

his exterior renovation work. The rate of dioxins released into the free air by the Spittelau power plant is practically nil: 0.1g per year! Such is the power of art! But to feel its true extent, one should go and contemplate the temple-palace of Spittelau by night, from the roadside along the Danube canal. One grasps then the poetic fervour with which Hundertwasser

Motorway restaurant, Bad Fischau, Lower Austria, 1989–90

has paid homage to the spirituality of matter, in the glorious sublimation of its biological cycle.

The term 'redesign' is applied to projects which, in addition to the works on the façade of a building, entail the layout and renovation of interior spaces. It is curious to note that the famous Italian post-modern designer Alessandro Mendini had employed the same term, redesign, around the year 1975, to define his reworkings of furniture belonging to the industrial production of the 1950s.

The redesign projects are numerous and varied. They range from the museum of folklore (Roiten village museum, 1987–88), the motorway restaurant at Bad Fischau (1989–90, ill. p. 49), the Martin Luther finishing school at Wittenberg (under construction since 1997), or from the "Village near Hundertwasser House" (Vienna, 1990–91) to the essential works which, from the spiritual and moral point of view, are of capital importance in the concrete explanation of Hundertwasser's design for society: the church of St Barbara at Bärnbach in Styria (1984–88, ill. p. 49, 50), the KunstHausWien (1989–91, ill. p. 51) and the department of oncology at Graz University Hospital (1991–94, ill. p. 52).

St Barbara is a modest country Catholic church, built in the difficult postwar years 1948–49. The initiative of the curate Friedrich Zeck was decisive. From 1984 to 1988, between his stays in New Zealand, an exhibition of engravings at Tahiti, the completion of the house in Vienna, the death of his dear friend Brô in Paris (1986), the transformation of the Palais des Beaux-Arts in Brussels for Europalia 87, the start of studies for Spittelau, and a summer course at the International Academy in Salzburg on naturist architecture, Hundertwasser found time to supervise the construction site of the church of St Barbara and to sacrifice himself without being able to count on the success of the enterprise, to the point of doing an engraving titled "Devotion at Bärnbach" to contribute to the financing of the works. He renewed the bell tower by crowning it with a gold onion, the main altar in silver rays and the sacristy. He covered the walls with a cladding of undulating ceramics and decorated

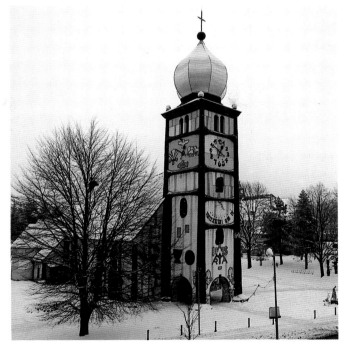

Saint Barbara Church, Bärnbach, Styria, 1984–88

Gateways of the Processional Way

Prehistoric religions: labyrinth and altar

Judaism: menorah and Star of David

Indian religions: Hopi sign and sun god

African religions: man and mask

Islam: Allah and the crescent moon with star

Buddhism: Buddha and the wheel of flame with gazelles

Hinduism: Om and swastika

Polynesian religions: tikis and Maori boat

3Shintoism: the rising sun with "Nihon" and yoke gate (torii)

Non-Catholic Christian religions: Bible for Protestantism, on the other side the Coptic cross, Jerusalem cross and orthodox cross

Confucianism: I-ging and yin and yang

12 arches at Saint Barbara Church for ecumenical reconciliation with important religious symbols, Bärnbach, 1984–88
The 12 gateways are primarily intended to mark off the grounds of the church, but they also assume the functions of the gateway: openness and invitation. The symbols stand for respect and tolerance towards other religions and cultures.

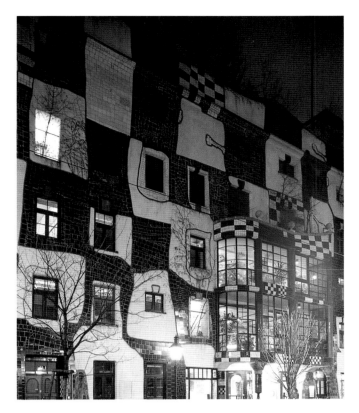

KunstHausWien, Untere Weissgerberstrasse, Vienna, 1989–91

the baptistery window with glass spirals. To assert the ecumenism of his planetary vision of spirituality, he multiplied the symbol-signs of the world's great religions, which he inscribed in celebratory tiled plaques on the pediment of porticoes distributed around the church in the manner of a Japanese "tori" park. The metamorphosis of the church rekindled the fervour of its worshippers and drew to Bärnbach an unexpected influx of tourists.

The KunstHausWien is, after the house and its "shopping village", the third panel of Hundertwasser's presence in Vienna, the cultural gem in the network of happy spaces installed by the dealer in happiness in the urban fabric of the city's third district. The old building that had housed the famous Thonet furniture factory has been refurbished in the oriental-naturist style, and converted into a museum with an exhibition capacity of 4000 sq.m. The two first floors are devoted to the permanent collection, an anthology of Hundertwasser's oeuvre, and the two top storeys house temporary exhibitions. Jean Tinguely inaugurated the programme. The ground floor is occupied by the reception, cash desk, café-restaurant and shop, which displays the full range of creative clothing, all the books and all the gadgets, from the Brockhaus Encyclopedia and Stowasser Latin Dictionary, from the scarves and fountain-pens to the wrist watches and posters, in short, everything necessary to satisfy the passing fan (ill. p. 89). The KunstHausWien is managed by Joram Harel, with Hundertwasser's blessing. The number of visitors to this private museum, which receives no state subsidy, amply exceeds that of all other Viennese public institutions dedicated to contemporary art.

At the request of both the oncology consultant at Graz University Hospital and the members of the association for cancer patients, Hundertwasser proceeded to rearrange the department. The specialists thought that the technical and sterile atmosphere of the hospital had an unfavourable effect on patients, especially on cancer patients, for whom psychological problems are of capital importance. Professor Samonigg took Hundertwasser literally. He turned to him as architecture's doctor and asked him to change the premises of his department into "happy spaces". The project, begun in 1991, was finally completed in 1994. Here again the artist contributed to the financing of the works by the publication of a lithograph printed in large numbers. Two years after the opening of the renovated department, the doctors conducted a survey among

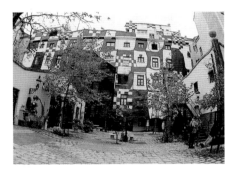

KunstHausWien from the courtyard, 1993

Hundertwasser on a terrace of the Hundertwasser House in Vienna, with Jean Tinguely, 1991

their patients. What influence might the refurbishment of the hospital environment and of their place of treatment have had on their state of mind and on their preoccupation with their illness and its course? The response, which has just been published in the medical trade press, is decidedly positive. The unequal rough-casting of the walls, the irregular floor tiles, the many-coloured doors with their twisted lintels, convex columns and painted coils, the asymmetry of the spontaneous decoration ... all these things indisputably help the patients to live better and to improve their condition. The doctor of the third skin has fulfilled his contract.

Oncology ward at the University Hospital, Graz, 1991–94

International scientific research testifies that architectural surroundings in harmony with nature and with man provided by Hundertwasser at the University Hospital at Graz are beneficial to patients. The same is true for children and grown-ups.

The projects for new constructions have developed at a steadily growing pace, as an ever wider public feels the increasing need to find in its habitat the immediate motivations for a better life. Clients today approach Hundertwasser not only to pass him orders for "happy spaces" – taken for granted by the supporters of his naturist moral precepts – but to commission "loved spaces". He was left to shout in the desert when he was taken for a vociferous philosopher, but he was summoned when he revealed himself to be an efficacious doctor. Now people would like him to operate as an alchemist of architecture.

The new projects denote a greater demand for quality of life. They are also more ambitious. "In the Meadows" (Bad Soden am Taunus, 1990–93) is the luxury version of Hundertwasser House: 17 flats from 140 to 250 sq.m, immersed in the deep green of surrounding fields and served by shops, garages and fifty garden-terraces.

The Heddernheim project, on

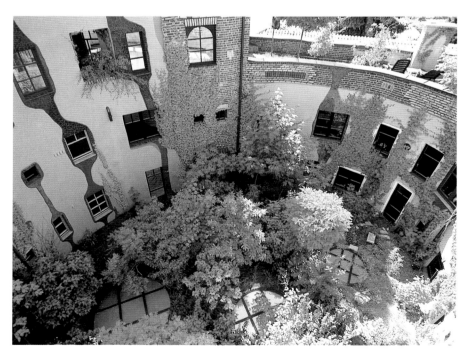

Residential complex "In the Meadows", view of the courtyard, Bad Soden in Taunus, 1990–93

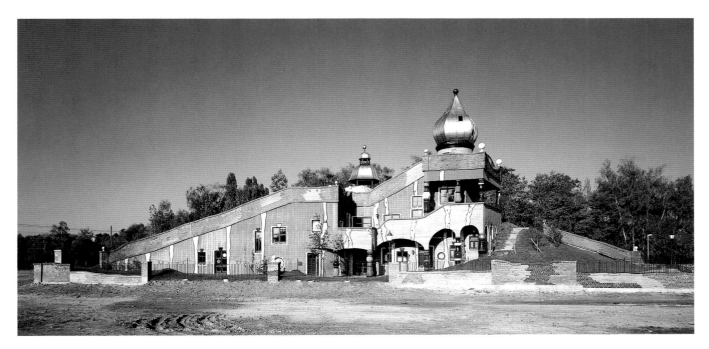

Day-care center of the City of Frankfurt, Heddernheim, 1987–95

the outskirts of Frankfurt (ill. p. 53), has been through endless ups and downs. Originally conceived as a kindergarten, the project soon took on the dimensions of a community centre, with the Catholic and Protestant churches facing each other. After all sorts of vicissitudes, the Frankfurt authorities and Hundertwasser went back to where they had started and the children's day nursery, formed by two crossed ramps crowned with gilded towers, was inaugurated on 22 June 1995.

Among the most recent projects, leaving out the "Countdown 21st Century Monument for TBS" (Tokyo, 1992, ill. p. 56), the Winery of Carl Doumani (Napa Valley California, 1988–1997) and a host of sketches stuffed into holders, one common feature stands out, namely that Hundertwasser's clients are seeing bigger and bigger. They are asking for a residential complex in the Canary Islands (work began in 1966), a Kids' plaza in Japan (ill.

p. 53), a wood spiral at Darmstadt (the concept of which was recently approved at the beginning of August 1997, ill. p. 57).

The plans for this green spiral are fascinating. A grass pitched roof shelters a troglodyte structure in layers of 130 flats spread over several levels, flanked by a castle keep crowned by a gold sphere. There is plenty to set one's mind dreaming about this spiral of happy living, resolved in a horseshoe.

Rolling Hills, a hot spring village in Blumau, in eastern Styria,

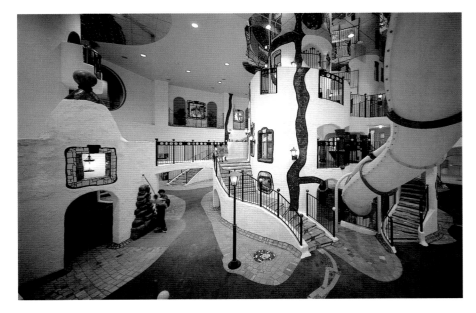

Kids' Plaza, a children's museum in Osaka (Japan), 1995–97

opened its doors to the public on 10 May 1997. The first contacts with the entrepreneur Robert Rogner, the project manager, date from 1990. It took seven years to complete the village, seven years of reflection and work that have established a firm friendship between Rogner and Hundertwasser.

Blumau is so far Hundertwasser's biggest project and the richest in future prospects (ill. p. 54, 55). One feels in it the shaping of the model for an ideal city resting entirely on the principle of harmony between man and nature. Blumau completes the Viennese urban triptych formed by the house, the village, the KunstHausWien and its super symbol-talisman at Spittelau. These major achievements are the striking sketch of a project for society.

Blumau presents itself as a hotel complex, the structural elements of which are scattered across a 35-hectare site. Initially Blumau could receive 1000 persons. Today it offers a capacity of 250 rooms, 550 beds, two freshwater swimming pools and five thermal baths.

The living areas are accommodated in the folds of the "rolling" grassy hills, which serve both as filtering humus roofs and as walks. Access from one area to another, from one hill-meadow house to the next, is per-

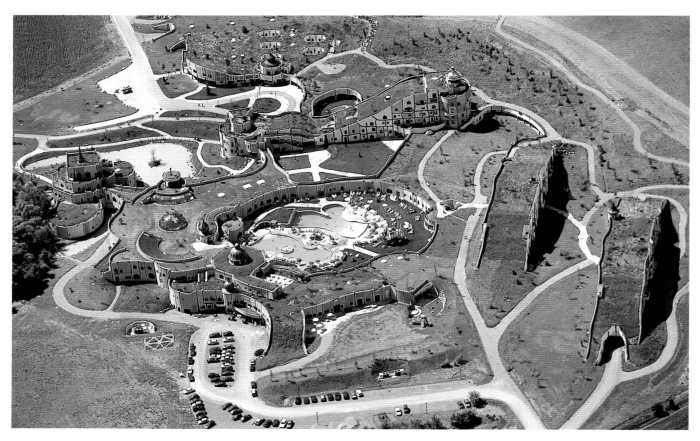

Rolling Hills, hot springs village, Blumau, Styria, 1990–97

fectly free. 1400 sq.m of aquatic spaces have likewise been fitted out. Subsequently new elements can be organically joined to them. The architectural morphology is inspired by the "models of architecture" created by Hundertwasser on his own, parallel to his painting or to his engravings, and in which he gives free rein to his imaginative fantasy. If the models are executed independently of the concrete projects, like sculptures, Hundertwasser finds in them the opportunity to deliver ideas, forms of habitat and propositions for urban planning. Certain of his ideas are taken up in his projects. Blumau to some extent affords a synthesis of the principal

types of naturist habitats expressed by the "models": the slit-eyed house, the grass-roofed house, the pit-house, the terrace-houses and the hill-meadow house.

The slit-eyed house is a grassy tumulus planted with trees, the north side of which is built into a wooded hillside and the south front of which opens onto a broad almond-shaped glazed and slit-eyed indentation (a reminder of Hundertwasser's eyes). The house is thus full of light, and its brightness can be further increased by installing light domes up on the turfed roof. It is the very image of the welcoming family dwelling, soundproofed and air-conditioned by the double layer of grass and earth, and perfectly ventilated. The pleasure of being able to walk about comfortably on the house reinforces its inhabitants' sense of possession of a "loved space", of a sure shelter and discretely privileged fragment of nature.

The house with the grass roof is the classic pattern of naturist hygienism. The grass roof is linked to the concept of humus toilets (1) and tree tenants; it purifies rainwater by filtering it and regenerating the cycle of vegetation through the humus of faecal matter. Imagine

(1) The humus toilets were tested in Vienna, in New Zealand, in Normandy and on the ship "Regentag" by Hundertwasser and will be an integral part of the ecosystem of his architecture. They do not yet figure in his present houses, but will be further programmed.

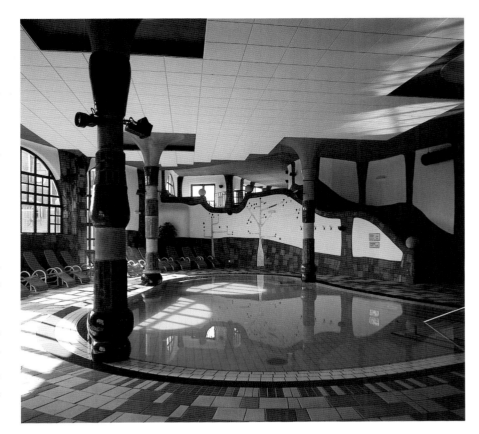
Indoor baths, hot springs village, Blumau, Styria, 1990–97

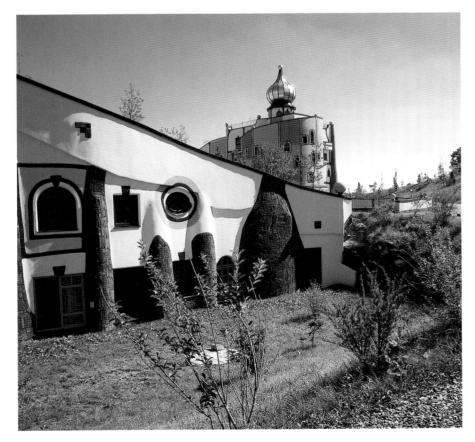
Wavy walls, hot springs village, Blumau, Styria, 1990–97

Hundertwasser's surprise when, on one of his first visits to New Zealand, he discovered the home of Ivan Tarule-vič, on the Bay of Plenty coast, with sheep grazing on the roof...

It was during his travels in Tunisia that Hundertwasser came across a type of open-sky troglodyte habitat, that can also be found in China. The houses were built into the vertical walls of the ground and their openings gave onto a central court which was a wide form of moat. The system of the house-moat, cool in summer and warm in winter, fosters the community life of a small group testifying to a strong specific identity.

The terrace-houses offer the simplest means of bringing together men and trees. The horizontal belongs to nature, the vertical to man. The parallel levels of the terrace-gardens meet the perpendicular presence of man and trees. That is why the man–tree relationship has to take on religious proportions, Hundertwasser tells us: "You will survive only if you love the tree as much as yourself."

A more sophisticated version of the terraced structure was presented in Munich in 1983, at the International Gardening Exhibition, where it aroused keen interest. The high-meadow house presents itself as a structure having three superimposed levels of houses-gardens-terraces linked by a vertical circulation. A house of this type is due to be built shortly in Dresden.

But during its first year of operation Blumau has already achieved occupation rates of 89 %, and in March 1998 Hundertwasser and the developer Robert Rogner were awarded the "Prize for Special Services to Tourism" by the association of German Travel Journalists. A visit to the site and the study of plans show the care taken by Hundertwasser in developing a double system of circulation, individual itineraries and collective activity areas, places for retreat and meditation, and spaces for dialogue. These networks are not imperative. They do not impose themselves: they are marked out only by the volumes and contour levels that follow the curves of the "landscaped" land. Hundertwasser remembered the study he did with Gustav Peichl in 1974 for the conversion

Countdown 21st Century Monument for TBS, Tokyo, 1992

of the Seilergasse in Vienna into a pedestrian precinct. One does not assign people to their happiness. Everything was done to invite them on a journey into happy spaces worth loving.

On the subject of architecture and planning it can be said that since 1972, in just fifteen years, Hundertwasser has thought of everything, from the happy man and woman's house to the magical palace of refuse, from the inspired church, temple of ecumenical humanism, to the taxi rank, from the restoroute, the filling station, the naturist motorway in a leafy semi-tunnel, to the public lavatories, from the hotel or from the hospital to the thermal baths or to the museum – not to mention the spiral-fountains and the redesign of watches, cars, aircraft, riverboats... after that of the coal washery and the grain silos.

Hundertwasser has peered into the innermost nooks and crannies of man's third skin. And so in the same period, the spiral of consciousness dilates and other sensitive levels appear, a fourth and a fifth skin. Hundertwasser is more and more passionately interested in the social environment and in the fate of collective identity. He denounces supranationality and combats a United Europe. Highly sensitive to the threats posed by science and its irresponsible offspring, technology, to the planet, he fights nuclear energy and pollution in all its forms, whilst keeping his distance from the politicians of ecology. He notes that the virus of the straight line spares neither the left-wing parties nor the greens and that often the spiral of conscience leads him, through his

opinion campaigns, to assume in his speeches and his posters, positions close to those expressed by qualified right-wing thought as far as the Austrian and European political scene is concerned. Everything happens as if, by taking up a stance on all the burning issues of today's situation, Hundertwasser had followed a party programme aimed at the ideal, virtually real man and woman, at the standard inhabitant of the happy spaces of his house in Vienna, the Kunst-HausWien visitor, the faithful at

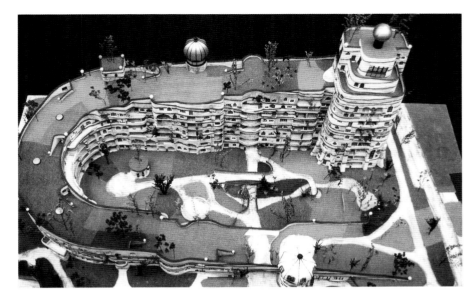

"The Wood Spiral of Darmstadt", model of a Hundertwasser architecture project for Darmstadt, 1996

St Barbara, the dustman at Spittelau, the patient at Graz or the health-spa guest at Blumau. Must that ideal human being, who is meant to have directly or indirectly assimilated the "Grammar of Seeing" and the "Mould Manifesto" before his respect for nature had let him glimpse the key to happiness in beauty, therefore be, ipso facto, pro-Semite and anti-Zionist; must he or she hate the Communist apparatus and dread the dictatorship of economic liberalism, feel a nostalgia for the old Austrian car number plates and struggle against a United Europe, encourage New Zealand to change her flag in order better to assert her national identity, and permanently test the limit-threshold of the growth of society in order to denounce ecologist demagogy?

In asking myself these legitimate questions, I have drawn up the standard portrait of the subscriber to a project design for society that would be signed Friedensreich Hundertwasser. And in effect one might well imagine the citizen of a neo-Babylon of terrace-towns and hanging gardens with brightly tiled pediments who would, parallel to a naturist worship of trees, flaunt water and shit, nationalist and pacifist convictions, the quest for quality in the amelioration of craft techniques, the myth of the good savage, and the desire to be governed by a good king, a wise and enlightened monarch capable of soothing the misplaced fervour of scribes.

The king: goodness only knows how much Hundertwasser loves that monarchic metaphor. It recurs frequently in his writings, and when a holy exaltation grips him in front of a picture, an idea, an impressive act, he feels like a king, a real king. In a text of 1982-83, he explained himself clearly: everybody can wear a crown and have themselves admired as a king. It will last an evening, and later he who felt like an usurper will run away. He who feels at his ease in the king's skin will persist in wearing the attributes of royalty. People will take him for a clown and make fun of him. But at that moment, "if he is strong, he will contrast that situation with something just as strong as the masses that mock him. And in that way he will then attain to a position equal to that of a king: he will become a king."

In fact Hundertwasser's monarchic outlook depends first of all on an aesthetic fact. He feels like a king in his art and by his art. The success of his painting has conferred the attributes of royalty upon him: the majesty of his immense talent, the humanity of his planetary vision. This eminent status gives him the rights and duties of which he is aware.

During two long recent meetings (Venice 1996 – Paris 1997), the painter-king opened himself up to me at

various intervals. The foundation of his project for society rests on beauty: Hundertwasser considers it in its dynamic totality as a work of art in progress, in perpetual progression, indivisible from his painting. For Hundertwasser everything starts from art and comes back to art. Nothing is lost and nothing is created outside art.

A famed and internationally acclaimed painter, he started his architecture at the age of 55. And he very quickly got down to the job, prepared as he was by his pictorial practice and by the constant meditation that accompanied it. A few dates will suffice to testify to the remarkable continuity of the global film of his thinking. Let us take its guiding thread: the tyranny of ugliness exercised by the straight line in architecture. With a gap of 30 years, two paintings visualize that evil with the same sacred ardour: "The Almost Circle" (1953, ill.p. 60); and "The Tyranny of Architecture – The Road to Socialism" (1982, ill. p. 61). The "Mould Manifesto" dates from 1958, the "Window Right" from 1972, the "Sacred Shit" from 1979.

Hundertwasser likes to tell an anecdote illustrating the anticipatory breadth of his pictorial vision. In 1985, the construction site of the Löwengasse house had risen to its 9th storey. I was struck by the stench of urine that reigned there. "The toilets are on the ground floor, so you can be sure the workers aren't going to waste a quarter of an hour going down to satisfy such a fluid natural need", came the answer from the foreman. Two paintings sprang to my mind: "Pissender Knabe mit Wolkenkratzer" and also the painting of the man pissing from the yellow tower, which I gave to Tajiri in 1953. There and then, I too pissed onto the building yard. The finished works effaced all its odours!

"My obsession with the quality of painting had prepared me for the problems attached to the quality of life, of the dignity of labour, of respect for nature, of the moral hygiene of ecology", a key phrase in Hundertwasser's vocabulary. The necessity for quality was also an idea cherished by Yves Klein, who made it the cornerstone of his blue revolution. Like Yves Klein, Hundertwasser has a nostalgia for the spirit of fellowship, which animated cathedral sites in the Middle Ages. Trades unions have today replaced the old guilds. They talk only of wages and working hours, and little about professional training. What I try to arouse among my workers is a savoir-faire gained through the exercise of their creativity. How could the ceramic tiles on my walls and my columns attain to such splendour in diversity without the free initiative of my bricklayers and tilers?

To the rationalist architects who reproach him for putting windows everywhere, for purely decorative or fanciful reasons in his houses as well as in his paintings, whereas the front of a building must express the inner logic of its functions, Hundertwasser replies that natural harmony is achieved in diversity and not in uniformity. The law of nature is the law of art: that of the aleatory play of spontaneous creativity. The most spectacular details of beauty in nature are to be seen in their utter gratuity. What is the use of the superb designs on butterflies' wings or on a peacock's feathers? Beauty is always functional, adds the painter-king. It is the basis of all the technological developments of ecology. And its proof is that I am convinced that the butterfly wings extensively spread to the sun are energy collectors that act in the manner of the photovoltaic panels used for solar heating, and more effectively still, thanks to the beauty of the design with which they are adorned and which contrasts with the geometric rigour of industrial collector panels.

It is the photographers that give functional architecture its aesthetic appearance. It is their art that creates things of beauty to be seen. For there is very little else left to the architecture of the "grid system", which has lost touch with artisan creativity. With Adolf Loos it banished ornament. There is nothing left but the illusion of functionality and compliance to budget restraints. Constructing badly at a cheap price merely increases the terrible social danger of pollution by ugliness. My constructions cost a little more than the routine planned norm. This slight increase has only a small effect on the project budget. The initial forecasts estimates for the Vienna house

put its cost at 50 million schillings. The final cost came to 80 million. At Spittelau the figures were as follows: 80 at the start, 100 at the end. The aesthetic investment in habitat has decisive consequences for the quality of life, for the workers in their work, for the inhabitants later in their daily lives, and this cannot be calculated in figures. A grass-roofed house costs at the very most from 5 to 10% more than a normal house, but what a difference to the quality of life in it, if one is to believe Malcolm Wells, an American ecologist architect who has conducted comparative studies on this subject, and whose figures Hundertwasser brandishes by way of reference!

One cannot help being struck by the radical violence and religious fervour with which Hundertwasser expresses his convictions in his writings and in his controversial campaigns. There is no compromise between beauty and ugliness. Truth resides in art, in its infinite, intuitive richness. The king of art assumes in his life the same rights and the same duties as those assumed in his painting. And these rights are duties. Art has given Hundertwasser the absolute duty to help people assume the essential relationship with nature so as to develop their creative instinct, and to preserve their freedom, their identity, their right to happiness. And to prevent them straying from the straight and narrow way, he offers them barriers of beauty, which are none other than the intelligent use of the uncontrolled irregularities engendered by nature's spontaneous creation.

The painter-king readily adopts an apocalyptic tone to denounce the immensity and imminence of the dangers threatening our society: the perpetual murder of beauty by ugliness culminates in the apotheosis of evil:

the formidable potential of death posed by nuclear energy. We shall be seeing shortly what retroactive quakes may cause the hair of Hundertwasser's fourth and fifth skins to stand on end.

The painter-king has all the qualities of a leader of men, starting from the clarity of his programme, the authentic fire of his commitment, the faith in his vocation, the persuasive force of his language and the attractive impact of his character. Why does he not found a party, instead of confining himself to solitary action with a handful of unconditional friends on whom he is more and more reliant? The answer lies in the power of art, which boosts his faith in success at times of crisis, and calms his voluntarist temptations by giving him the certitude that time is on his side. His ideas and his houses speak for themselves, as do his paintings. The affirmation of the truth is ineluctable when it takes the path of beauty. Without ever tiring, the painter-king sows his fields with future harvests.

Good and bad notes for houses by the architect Malcolm Wells

175　*The Almost Circle*, Oil on wood,
59 x 140 cm, Saint-Mandé
(Seine), 1953

Even on ruler-conceived straight streets
the trace of man evolves in organic lines.

The Tyranny of Architecture — The Road to Socialism, Mixed media, 97 x 129 cm, New Zealand, 1982

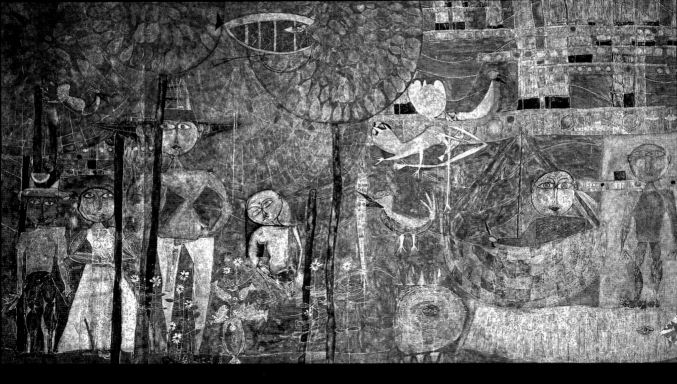

96 *Land of Men, of Trees, Birds and Ships,* **Mural painted in collaboration by René Brô and Hundertwasser, 2.75 x 5 m, Saint-Mandé (Seine), 1950**

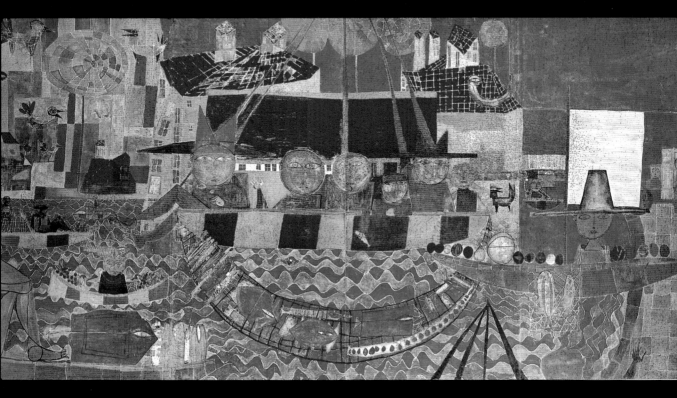

97 *The Miraculous Draught,* **painted on panels in collaboration by René Brô and Hundertwasser, 2.75 x 5 m, Saint-Mandé (Seine), 1950**

THE FOURTH SKIN: THE SOCIAL ENVIRONMENT AND IDENTITY

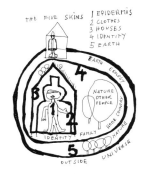

Hundertwasser became only belatedly conscious of his fourth, family skin. An only child, whose father died when he was an infant, his family life was limited to an exclusive relationship with his mother, in the form of a visceral attachment and deep ironic tenderness. Elsa Stowasser, a bank clerk and Jewish mother, incarnated the petty bourgeois values of her time. "Stay anonymous if you want to live in peace", she told him. When she realized that a "different" personality was awakening in her son, she felt deeply afraid. The painter's early successes, which she had time to witness, did not allay her apprehensions. When she died in 1972 Hundertwasser came to a decisive turning-point in his career. He became from then on much more sensitive to the social environment and to the identity problems linked to a group, community or nation.

The hypersensitive and solitary adolescent discovered a second nature in the adventure of travel. That nomadism, never since belied, has given him the opportunity to visit the whole world. It allows him today to tour the residencies that he has collected around the globe, in Austria, France, Venice, New Zealand.

In 1949, at the age of 20, he left Obere Donaustrasse in Vienna to roam the length and breadth of Italy. It was there that he met René Brault, a French painter who called himself Brô and who was to become the first member of his new family, that of his friends, or more exactly, of his elective affinities. Brô, whom he later followed to Paris, was to play a decisive role in Hundertwasser's life, in the establishment of the man and his œuvre. The painter-king is infinitely grateful to Brô "for having opened the door to beauty" to him. This privileged relationship between the two artists was conveyed by a mutual borrowing of each other's vocabularies. I made an exchange with Brô, Hundertwasser tells us. He allowed me to paint the "bei occhi", the almond eyes set very high

Hundertwasser and René Brô in the Waldviertel region of Lower Austria, 1978

190 *La Terre Allemande*, Watercolour, 35 x 53 cm, Rome, 1954

up in a round face. These were the eyes of his wife Micheline but they also exist in the mosaics of Ravenna or in Siennese painting. His eyes became mine. I, on the other hand, gave him the right to paint round and radiant trees, "the soul trees" and their halo which I had seen in the paintings of the German painter Walter Kampmann. My round trees became Brô's trees. They did mural paintings together at Saint-Mandé, in 1950. Although their careers developed at different paces, Hundertwasser stayed loyal to his friend Brô right up till his death in Paris, in rue Galande in 1986. They had resumed their nomadic wanderings on several occasions. They had spent the winter painting together in Lower Austria's Weinviertel region in 1978, they went together to India, to Nepal and to New Zealand in 1981.

Brô was the model for the relationship of existential complicity and spiritual intimacy that Hundertwasser had been looking for since 1972, to help him face the practical problems that had beset him on all sides of his committed activity. This concept of "collaboration" bears a significant similarity to the kind practised by Yves Klein with the sculptor Jean Tinguely, the architects Walter Ruhnau and Claude Parent, and the designer Roger Tallon. In 1959 Hundertwasser had already founded in Vienna the "Pintorarium", with Ernst Fuchs and Arnulf Rainer. These three profoundly different painters had found themselves on the same wavelength and eager to set up "a breeding ground for developing a creative élite", a project closely contemporary to Yves Klein's "School of Sensitivity".

In 1972, Joram Harel entered Hundertwasser's life and placed at the disposal of the painter-king all his creative drive. Hundertwasser had the ideas. But to put them into practice, he needed highly qualified specialists who shared his convictions and understood his spirit. For the house in Vienna, the city council sent Hundertwasser the architect Peter Pelikan, and their meeting proved providential. The two men got on splendidly, and Pelikan has by now done most of the plans for the artist's major projects, from Spittelau to Graz or Blumau. The same intellectual rapport was established with Alfred Schmid, the designer of the architectural models, or with Wolfgang Seidel, the postage-stamp engraver, with Claudio Barbato, the silkscreen master in Venice, or Wörner, the printer of posters and postcards. The list gets longer as each day passes, at the polymorphic, practical and affective pace of militant creativity set by the king of this little world, namely: the entrepreneurs and the project managers that have entrusted him with key projects, the art writers and museum curators who have passed on his message, the Regentag crew, a few friends in Paris and a few farmers in New Zealand, an African president and two... Viennese

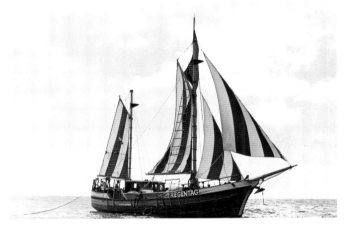

The ship "Regentag"

astrologists. Despite the risk of forgetting some, Hundertwasser wanted to write down in my presence the list, which I have put at the beginning of this book, exactly in his order of enumeration. And in so doing I am simply underlining the vital importance attached today to this fourth skin of proximity in the existential pattern of Hundertwasser's life. Each member of this family directly shares the same affective and concrete relationship with the painter-king, exactly as in the case of those other dealers in planetary dreams: Christo and Jeanne-Claude.

The fourth skin does not stop at this family level, natural or acquired. Its social milieu extends to the associative groups managing the life of a collectivity. The nation today still offers the thickest community web, albeit

Hundertwasser aboard "La Giudecca" in Kaurinui, 1997

threatened in Europe by the edification of a supranational system. The collapse of the USSR or the explosion of the Yugoslav federation have seen the birth or rebirth of new nations, whilst the African crises point up the fragile identities of territorial entities inherited from colonial days. The inextricable nature of the situation in the Middle East stems from the allergic gap between two different senses of identity.

The project for an aesthetic-naturist society had a pacifist facet to it. Peace in beauty is the sovereign expression of natural order, universal harmony. In "Friedensreich" Hundertwasser's vision, beauty engenders peace, in a manner as necessary as it is sufficient: the inhabitant of happy spaces is at peace with himself and his neighbour. The parishioner of St Barbara feels closer to God, the Graz patient surmounts the stress of his or her cancer, and taking the waters becomes a recipe for happiness at Blumau. The geopolitical situation in the world today shows, alas, that peace is not closest to the hearts of all nations, and that in many cases the ways to universal harmony, those of beauty and peace, appear as asymptotes whose parallel paths appear doomed never to meet.

Realising the impact of the national idea on citizens who recognize themselves in it, Hundertwasser has been very closely interested in the distinctive signs of identity. The most immediate features by which the identity of a nation is asserted, in respect to its citizens and the world, are postage stamps, flags and … car number plates. In a remarkable visionary breadth, Hundertwasser thus passed from the architectural macrocosm to the microcosm of the postage stamp. From the super-large to the super-small, everything is important.

Hundertwasser's genetic memory has registered his privileged relationship with stamps. From his father whom he never knew, he inherited a collection of stamps which he had to sell to pay for his first exhibition in Vienna, at the Art Club in 1952. "I loved stamps long before I became a painter", admits Hundertwasser, who adds a charming anecdote: "I used to write letters, quite simply, to an 'Unknown philatelist' in a city with an exotic name picked from an atlas… and I would receive about one answer for every three letters sent. Then we would exchange stamps…"

The pigsty in New Zealand, 1998

The child-collector who thus cast bottles communicating his passion for stamps into the sea of chance became, in 20 years of a career during which he designed some thirty or so models for stamps, a worldwide celebrity in the field of philatelic art (ill. p. 69). In 1979 the President of Senegal, Léopold Sédar Senghor, turned to him for a Senegalese set of postage stamps. In 1984 Hundertwasser won the prize for the best stamp and the gold medal from the President of Italy, Sandro Pertini, for the 1.20 Swiss francs stamp of the United Nations in Geneva. From 1991 to 1993 he was official coordinator to the Principality of Liecht-

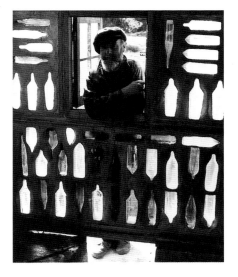

Hundertwasser in the Bottlehouse, New Zealand, 1982

enstein for the philatelic series "Homage to Liechtenstein". The stamps designed by him in 1995 for the United Nations are the subject of a special postmark commemorating the 25th anniversary of a major institution, the "Premio Internazionale Asagio d'Arte Filatelica". At the Philatelia 1997 show in Cologne, he received the Grand Prix for Philately.

His first commission dates from 1975 and the others came regularly from then on. But the main period of production was anticipated by a stamp issued in Cuba to celebrate in 1967 the visit to Havana by the artists and works of the "Paris Salon de Mai". The cartoon was inspired by one of Hundertwasser's paintings, "Noche de la Bebedora" – night of the (female) drinker – which had been much noticed at the time. It is moreover the only stamp that refers to a painting. Following his first official commission to design Austrian stamps, Hundertwasser acquired the habit of executing for each stamp a number of rough sketches, in watercolour on paper or in mixed techniques, in an average format of 30 x 25 cm, about seven times larger than the normal scale. These are for the most part engraved in the size desired by Wolfgang Seidel, an expert on the subject and member of honour of the supreme circle of the painter-king's fourth skin.

In 1975 Hundertwasser was invited by the Austrian Post Office to inaugurate its "Modern Art in Austria" series. And it is hardly surprising that he chose to celebrate his entry into philatelic art with the mainspring of his oeuvre, the spiral, which had heralded 22 years earlier the transautomatism of his "Grammar of Seeing". The 4 schilling stamp of 1975 has today become a rare collector's item, after having got off to a difficult start (a German post office worker had refused, despite the Austrian postmark, to forward the postcard on which it appeared and had returned it to the sender with the words "This is not a stamp"). The Austrian Post Office now issues a stamp each year by a national artist whose name is proposed by Hundertwasser and Walter Koschatzky.

A student at the Ecole Normale Supérieure de la rue d'Ulm, Léopold Sédar Senghor, just like his fellow-student Georges Pompidou, had mingled with the cultural

Hundertwasser's old farmhouse in Kaurinui Valley, 1973. The house was shipped there through the Mangrove canal about 1930.

life of the Left Bank. The stray painter and his bizarre apparel had caught his eye. He had read his writings and manifestos and visited his first exhibitions in Paris, and gained a lasting impression from them. Hundertwasser for his part had met him at one of his private views, but had since forgotten about their meeting. Nothing would then have suggested that this young black teachers' training college student studying for his top grammar exam would have one day become President of Senegal and the great humanist apostle of Negritude.

When President Senghor opened the Salzburg Festival in 1977, he cited three names of creators who in his eyes represented "Austria as the expression of universal civilisation": a musician, Mozart, a poet, Rilke, and a painter, Hundertwasser. The president asked to meet the artist and that encounter consolidated their friendship. Senghor invited Hundertwasser to Dakar. Hundertwasser designed three stamps which were engraved by Seidel at the Austrian State Printers and issued in Senegal on 10 December 1979. "The Black Trees", the "Head" and the "Rainbow Windows" followed the 4-schilling "Spiral" and completed the revolution accomplished by Hundertwasser in the art of stamp designing. The multiple impression of colours has something prodigious about it. It combined heliogravure with a screen to create bright colours from yellow to silver, turquoise green and ultramarine blue, and a soft spot for black and various other shades. The stamp glue was specially created for the tropics. In short, these little stamps are great pictures measuring 32.25 x 42 mm.

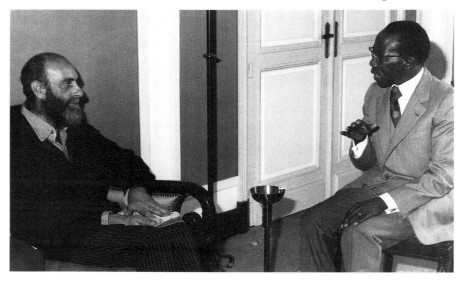

Hundertwasser with President Léopold S. Senghor of Senegal, 1978

In his preface to the presentation of the series, Senghor heaped praise on Hundertwasser, one of the world's greatest painters whose love of Senegal, "the black Greece", had moved him to offer to paint the original works from which these stamps originated. But his admiration proved to be of a prophetic lucidity: "Rooted in the realities of his time, he creates, beyond those realities, a world more beautiful but also more just ... The painter Hundertwasser reveals to us with a new vision, a new consciousness of the world." If one day the lands fashioned by Hundertwasser are federated into a territorial community, if one were to speak of Friedensreich's autonomy as one talks today of Palestinian autonomy, there can be no doubt that Senghor would have his place in the pantheon of great men in that happy space.

Hundertwasser's philatelic reputation was by now consecrated. Conscious of the immense far-flung power of postal communication ("Black Trees", the 60 franc CFA was issued in 300,000 copies, plus 17,500 special impressions), Hundertwasser devoted his philatelic production to the images that he likes, that is, to those illustrating his innermost convictions. Thus on several occasions he has designed stamps to commemorate the sessions of international institutions whose themes come into the line of his thinking. One such case was that of the United Nations in 1983 (New York, Geneva and Vienna), for the occasion of the 35th anniversary of the Universal Declaration of the Rights of Man. The titles of his stamps are significant: "Treaty with Nature", "Right to Create", "Homo Humus Humanitas", "Right to Dream", etc. The spiral illustrates "the right to create", and a patchwork of façades illustrates "the window right", a group of characters wearing asymmetric gaily coloured clothes and green caps over their almond eyes, "the second skin".

It was again under the auspices of the United Nations that he designed the stamps for the World Social Summit at Copenhagen in 1995, and also for the Summit series of the Council of Europe in Vienna in 1993: that is to say, for the geographic ensemble of all the nations forming the continent, and not for a united Europe,

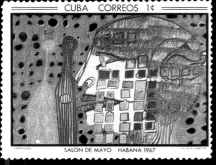

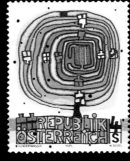

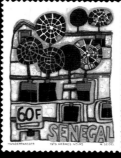

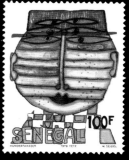

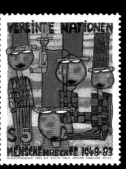

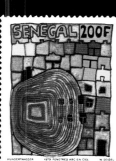

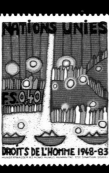

Hundertwasser original-designed postage stamps:
Stamp of Cuba, 1967: *Noche de la Bebedora*; Austria, initial series "Modern Art in Austria", 1975: *Spiral Tree with Yellow Edge*; Senegal, 1979: *Black Trees, Head, Rainbow Windows*; United Nations, on the occasion of the "35th Anniversary of the Universal Declaration of Human Rights": The right of creation, *Window Right, Treaty with Nature, The Second Skin, The Right to Dream, Homo Humus Humanitas*; Cabo Verde, 1982: Cabo Verde Steamer; Europalia 1987: *Hundertwasser House*, drawing by A. Böcskör; Liechtenstein, starting the series "Homage to Liechtenstein", 1993: *Black Hat Man*; Summit of the European Council in Vienna 1993: *36 Heads*; United Nations, World Social Summit, Copenhagen 1995: *The Tinkers, Le Vivat, Here is the Land*; Luxembourg, "European Cultural Capital 1995": *Antipode King, The Small Way, Arcade House with Yellow Tower*

nor again, for the Europe of the twelve five-pointed stars against which Hundertwasser has declared war!

Hundertwasser is attached to the small states whose survival gives Europe its peculiar character and also its hope, on a par with the Swiss cantons, of a more direct democracy and of a more just administration of public affairs. He accepted the proposition put to him by the Post Office of the Principality of Liechtenstein: to inaugurate, and thereafter to coordinate the series of stamps named "Homage to Liechtenstein" (1991–93). The artists he chose were Tinguely, Wunderlich, Baj and Brô. When Luxembourg became the European cultural capital in 1995, he agreed to commemorate the event. One of the three stamps that he designed, "Arcade House with Yellow Tower", was inspired by a watercolour done in 1953, the sketch for the famous painting which he had given at the time to his friend Tajiri.

In a text dated 14 Febuary 1990, Hundertwasser wrote some very beautiful things about stamps. I mention some of them here, which illustrate his humanist vision better than any conclusive analysis: "The stamp must experience its destiny… A true stamp must feel the tongue of its sender when he or she licks its glue… The stamp must experience the dark inside of a letter box. The stamp must bear its postmark. The stamp must feel the postman's hand when he delivers the letter to its addressee. The stamp that has not been sent on a letter is not a true stamp, it has never lived… This precious piece of art reaches everybody as a present coming from far away. The stamp must bear witness to culture, beauty and human creativity."

The most mobile mark of national identity becomes the most effective vector to convey the message of universal harmony. The images represented on Hundertwasser's stamps are lovely bearers of peace. They have an official value that "franks" them in the eyes of the sender and of the recipient from all aggressive censorship and from all violent surcharge. Hundertwasser the philatelic artist has brought us proof of the perfect usage of his code of moral practice. If only he could have brought about the same revolution in numismatics! Friedensreich is not yet, alas, permitted to mint money. The few coins that the artist has made (ill. p. 71), though without any universally recognized exchange value, remain a fine artistic currency – as fascinating in their irregularities mastered by a perfect technique as the other objects designed by their creator, the astonishing series of watches, notably, with the "Time drops" of Dalinian inspiration, and the wristwatches of the seven days of creation. The models of telephone cards or casino chips are on the other hand to be credited to the practice of "active communication" (ill. p. 71).

Hundertwasser lives his Judaism in a serene manner. He is Jewish just as he is a painter, it goes without saying. And this Austrian painter feels like a citizen of the world of which he has shaped a new image, that of a happy space in beauty. Beauty engenders peace: peace in beauty is the sovereign expression of the great natural order, universal harmony. The real world that we live in is that of the antagonism and clash of identity awareness. The Middle East situation presents the most irreducible example. The fanatical Zionists and the Muslim fundamentalists are separated by a wall of hate and a river of blood.

Watch of the Genesis edition: *3rd day: Divide the land from the waters*, 1995

Like entry tokens to Paradise, 1998

(787) **Onion Rain**

(788) **Window Spiral**

(789) **Floating Meadows**

(791) **Wavy Face**

(794) **Steamer from Front with Ships**

Front and reverse side of the four puzzle phonecards for the Austrian Postal Service

All of these Hundertwasser-designed Casino Austria Chips are different from each other.

Hundertwasser's irregularly shaped double-faced watch. With hour digits on the outer ridge.

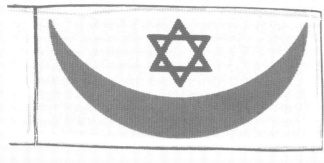

Peace flag for the Holy Land, 1978

Koru flag for New Zealand, 1983

Uluru, Down-under flag for Australia, 1986

How can the mutual allergy manifested by the two exacerbated identities be surmounted? By acting on the symbols that are its mark, the green crescent of Islam and the blue star of David. Opposed, the two symbols catalyse violence and war; united they are a factor of peace. They express at once its hope and its ineluctable necessity.

This metaphorical message, which can also be neatly adapted to the verbal circumvolutions of UN speeches, was materialised by Hundertwasser in a concrete way in 1978. His flag for peace in the Middle East depicts the blue star resting on the green crescent against a white ground. The symbol of reconciliation between the Jewish and the Arab peoples was intended to flutter over a united Palestine. How was that message to be conveyed and the idea of a flag for the promised land promoted? The answer was, by applying to the Austrian Chancellor Bruno Kreisky and asking him to back the project, as the head of a government of a constitutionally neutral and pacifist state. The suggestion, which came from Joram Harel, paid off. Bruno Kreisky accepted Hundertwasser's proposition. He sent the flag and its accompanying manifesto to the heads of state of the Middle East. The response was not long in coming, prudent and amiable on the Arab side. Shimon Peres was more direct. He took advantage of a visit to Vienna to confirm personally to Hundertwasser what he had told

him in writing: that to adopt the flag would be to put the cart before the horse... For ten years, Hundertwasser's emblem was stuck on the front door of my previous flat. After seeing it each day I had grown accustomed to it, the dream had become reality... the chiefs of state are not so patient!

1983: after ten years' residence in New Zealand Hundertwasser had become a privileged actor-spectator of that country's existential climate. New Zealand is English but also something else: 15% of the population are Maori. The decimated group was in the process of demographic expansion, mainly thanks to mixed marriages. The Maoris got there before the whites, but they are not Aborigines. The tree fern, the national plant, was also there before the Maoris, who adopted it in their tattoos. The sporangium unwinding from the fern represents at once the specificity of New Zealand nature and the Maori presence (ill. p. 72).

In relation to its Anglo-Saxon identity, New Zealand is in the process of developing a different parallel identity. The two levels of consciousness of being still live their difference normally. Hundertwasser felt that the time had come to signal that state of fact, through the design of a second flag, worthy to fly alongside the Union Jack.

And only the fern spiral could have inspired it: the Koru, designed in 1983, shows the green sporangium

Hundertwasser with Koru flag for New Zealand

unfolding on a white ground. A black vertical stripe on the edge stresses the beginning of its form.

By his declarations and manifestos, Hundertwasser unleashed a veritable opinion campaign on the theme of "A Flag of Our Own". His sentiments were shared but the interest was great among public opinion too, in the press and in parliament. After a three-year campaign, in February 1986, when 70,000 visitors rushed to the opening of Hundertwasser House in Vienna, 1000 Koru flew on roofs and façades in New Zealand. The painter-king had hit the nail on the head, on the tip of the consciousness of an autonomous national identity. It was only a matter of waiting, and time was on the side of the Koru.

Hundertwasser lives north of Auckland, near Opua on the Bay of Islands, 35°19 latitude south and 174°9 longitude east. The village of Kawakawa is just nearby. Its old post office built of kauri wood (the giant tree 2000 years old, almost as symbolic as the fern), was the main local attraction. This was to be destroyed to make way for a new, more efficient building. This attempt on the historic Kawakawa heritage inflamed "Frederick" Hundertwasser. He alerted the authorities in Wellington and founded a very active "Committee of citizens for the conservation of the old post office". Opinion there again was divided, and the idea of protecting the heritage had a long way to go. The controversy dragged on for two years. The decision to build the new post office was finally taken. But a deliberate fire settled the problem.

During a stay in Sydney in 1986, Hundertwasser drafted the project for a new Australian flag, Uluru: a long red segment of a semicircle reversed on a deep ultramarine ground; a seven-pointed white star standing in the middle of the blue. The red semicircle represented the reversed profile of Ayers Rock, the sacred mountain of the Aborigines (Uluru). The seven-pointed star in the middle of the blue depth of the Austral hemisphere symbolized the seven territories of the nation. Uluru was received with as much sympathy as caution. Prime Minister Keating did in any case present it on television. A promotion committee was put in place. Things slowly took their course.

The best asset possessed by the Koru and the Uluru is their beauty: their clarity and formal cohe-

The Kawakawa Post Office Building, built with Kauri timber in 1912, postcard published by the Bay of Islands Citizens Committee for the Preservation of the old Kawakawa Post Office Building

Cartoon about the Hundertwasser campaign to preserve the old Kawakawa post office building, New Zealand, in: "Northern News", 10 March 1983

Hundertwasser's proposal to maintain the Austrian tradition of car number-plates with white reflecting letters and numbers on a black background.

rence make them the emblems of an evident, specific and immediately recognizable identity, the strong signs of a future destiny. The Union Jack has ceased to cast its shadow across the southern cross. Hundertwasser is very much aware of that. He is particularly fond of the Koru spiral. During the year of tolerance, decreed by Frederico Mayor in 1995, Pierre Cardin published for UNESCO the six flags of tolerance. Each emblem represents a part of the world. He turned to Hundertwasser for Europe. The artist took up the Koru spiral, changing its colour. The dark sombre green of southern nature became the light blue of hope. The whiteness of the background remains a message of peace, and a vector of universal tolerance. By comparison to the other designs with their decorative and talkative images, Hundertwasser's proposition was the only one that had the air of being a real flag. The relation to the theme is rigorously conceptual and not discursive.

The interest shown by Hundertwasser in the defence and illustration of the heritage of identity, and which goes hand in hand with his ecological commitment, was translated into a renewal of his teaching activities. In 1981, we were a long way from 1959 and from the protest episode of Hamburg. The times had changed. The school could and had to become the happy space of creative beauty. The painter-king, named professor at the Fine Arts Academy of Vienna – in the very place where he had not stayed more than three months when he enrolled there in 1948 – drew up the "Guidelines for a Hundertwasser Master School", which his assistant Peter Dressler undertook to apply. The year 1988 was to be one particularly charged with militant initiatives. Hundertwasser gave a course on the subject of the naturist architect at the Salzburg summer academy and found the time, whilst in the midst of completing the Bärnbach site, to draft the manifesto for "Cultural Austria Against the Deportation and Destruction of Villages in Romanian

Transylvania"! But he flung himself most of all into a headlong campaign against the decision by the Austrian state to change the design and colour of car registration plates.

Except during the Anschluss (1938–45), Austrian car number plates had since 1930 carried white letters and figures on a black ground, as in France, for example, in contrast to Germany whose black figures were inscribed on a white ground. The socialist bill based the adoption of the German model on technical questions (brightness, reflection). Between 1988 and 1989 Hundertwasser threw all his strength

Cartoon: "A Hundertwasser for every Austrian", in: "Neue Kronen Zeitung", Vienna

Number-plate bus in action in front of the Houses of Parliament in Vienna, April, 1989

into proving that the black plates were just as – if not more – reflective as the white ones of which the multinational 3M (Minnesota Scotch) held the monopoly. He polished up and perfected old models (ill. p. 74). During the interminable battle of experts that ensued Hundertwasser's position aroused an immense echo in the media. The popular controversy ended up with a vote in parliament. The right wing members were for the black plates. Each deputy had moreover received from Hundertwasser a specimen of his project, corresponding to the number plate of the constituency for which he or she had been elected. The debate went on into the early hours of the morning. In order not to break the unity of the coalition in power, the Volkspartei voted in favour of the socialist plates. A failure therefore, but at the same time a moral semi-victory for Hundertwasser who had at least succeeded in provoking a government crisis. A semi-victory that witnessed the awakening of public opinion on the subject of this sign of national identity, and which left the way open to a re-examination of the question when the next legislation came into office.

Much ado about a matter of detail, you may say. Hundertwasser did not hold that view. His brilliant power resides in the homogeneity and coherence of his all-embracing vision. Hundertwasser's geopolitics rest on national identity, on the compactness of the diverse signs that convey the specific difference of a nation. He feels European in the measure in which he feels Austrian. Aside from sentimental and cultural factors, his attachment to Austria is linked to that country's geopolitical morphology. Its territory is reduced to a congruous portion: the German-speaking zone of the former Austro-Hungarian Empire. Its present format, based on a

948 **Sticker to fight Austria joining the European Union, 1994**

compact population stock, has enabled it since 1945 to develop a realistic democratic policy closer to the primary interests of citizens than that practised by larger nations. This local pragmatism, to which is added

Cartoon: "The Island of the Blessed", in: "Profil", No. 20, 16 May 1994

the statute of neutrality, has detached it from Germany to bring it closer to Switzerland, whilst nevertheless maintaining a close flow of east-west exchanges. In the painter-king's aesthetico-naturist perspective, Austria is not too badly placed on the comparative scale of the quality of life. Hundertwasser has already managed to win a number of battles and to take up a great

Hundertwasser architectural model, Museum for Wellington, New Zealand, 1988

moral challenge, extending from the refusal of nuclear power to the campaign against genetic manipulation. He has built happy spaces, the eventual proliferation of which would set the tangible start for a project for society geared to happiness in beauty. One should beware, then, of anything that may jeopardize that new national identity for Austria, and its essential diversity in the concert of neighbouring nations. Each element of distinction carries the same importance within the global profile of difference.

Hundertwasser is thus a partisan of the Europe of nations, of a Europe of diversity, where together with major countries like Germany, France, Britain and Italy, there exist tiny entities like Liechtenstein, Monaco, San Marino, Andorra and Luxembourg and smaller-model communities such as those of Austria, Switzerland or Slovenia. His opposition to Austria's entry into the European Union has been radical and continuous, and he still holds the same firm positions. He has watched with attention the anti-Maastricht stances adopted by certain authors and politicians and has included them in the special circle of his fourth European skin. We cite, among this network of elective affinities, Jimmy de Goldsmith ("The Trap"), whose recent death he mourns, Leopold Kohr (Das Ende der Grossen), E.F. Schumacher (Small Is Beautiful), Henry Coston (The Europe of Bankers), Alberto Miele (Let Us Drive the Merchants out of the Temple of Europe) or Denis de Rougemont (Europe Must Be Made for Diversity). Among the politicians his sympathies lie with the iron ladies of national identity, Margaret Thatcher, Marie-France Garaud, Elizabeth Guigou.

The campaign against a united Europe has hardened Hundertwasser's attitudes. In a fundamental text he declares: "To adhere to the European Union is to betray Austria": to betray its eastward vocation, to create a neurosis of annexation, a neo-Anschluss by submission to the mafia of supranationals, to betray its neutrality, the foundation of its national identity.

Austria the new Ostmark will not be able to maintain its position as a neutral, ecological and non-nuclear nation. The vassal state will sacrifice its small farmers, the last guarantors of a human management of the land in accord with nature. The supranational and multinational computers of Brussels will flatten out the specific differences of today's Austrian

Hundertwasser in his rainforest, New Zealand, 1998

humanism and that standardization will wipe out all hope of happy spaces. Hundertwasser sees in a united Europe the obliteration of his project for society and the permanent erasure of the few traces that he has left deposited on Austrian territory.

In support of this apocalyptic vision, he underlines the identity-void of the blue flag, hit by its twelve gold stars in a circle. Each state is represented by a five-pointed star. Hundertwasser knows that five-pointed star only too well – it is an occult sign, strange to European heraldry, and the mark of oppression and colonisation. He sees the trace of a normalising pentacle under the Union Jack in the flags of Australia and New Zealand. He sees in the flag of the European Union the plagiary of the stars and stripes of the U.S.A. In the upper blue field, the five-pointed stars symbolize the slavery of each state to the uniformity of union. At the beginning, when the union was limited to the states that had emerged from the former colonies, the stars, even they! – were set in a circle. The five-pointed star is likewise found on the red flag of the people's republics.

To see the fate of a united Europe through the negative symbology of the five-pointed stars of its flag is to see it from the angle of the painter, from the angle of beauty, where ethics and aesthetics meet. The painter-king therefore assumes all his rights. He predicts for united Europe the fate of the Titanic, and the imminence of the wreck of the Maastricht ship, which is leaking on all sides, reassures him. Phew! let us ignore the frontiers against nature that cut into our fourth skin, and rediscover the barriers of beauty that condition our vision of ecology on a planetary scale.

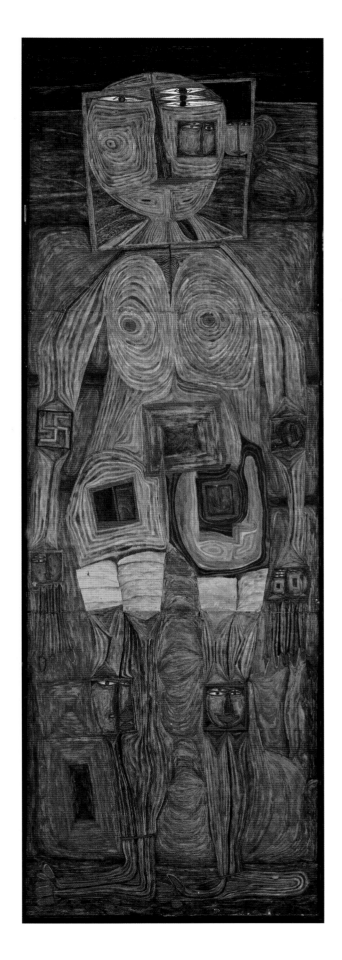

(178) *The Political Gardener*, Mixed media, 168 x 55 cm, Melun, 1954

Political symbols are beautiful when detached from their ideological meaning. Here the swastika is in the green of hope and the hammer and sickle are in cardinal purple.

DIE HUMUSTOILETTE ARBEITET AEROBISCH MIT HUMUSBAKTERIEN
FEUCHTIGKEIT WÄRME UND LUFT● LUFT MUSS VON UNTEN UND
OBEN DURCHZIEHEN KÖNNEN● WENN FLÜSSIGKEIT IN WANNE
KOMMT: ZU NASS● AUFHÖREN FLÜSSIGKEIT ZUZU GEBEN.●
WENN ZU TROCKEN MIT WASSER GUT VERTEILT BESPRÜHEN BIS
FLÜSSIGKEIT IN WANNE KOMMT● Z.B. MIT WASSERSPRAY●
WASSER IN WANNE WIEDER OBENDRAUF GEBEN ODER PFLANZEN
GIESSEN● SCHEISSE SOFORT, KÜCHENABFÄLLE WENN SIE RIECHEN
MIT FEUCHTEM HUMUS SORGFÄLTIG ABDECKEN● GERUCH UND FLIEGEN
VERSCHWINDEN SOFORT● WENN VOLL (2 PERSONEN 2 MONATE)
EIN MONAT STEHEN LASSEN● DANN EINMAL PRO WOCHE UMSCHAU=
FELN BIS LOCKERER GUTRIECHENDER HUMUS ENTSTEHT● INZWISCHEN
EINEN ZWEITEN BEHÄLTER BENUTZEN● GEWONNENER HUMUS
ZUM ABDECKEN WIEDER VERWENDEN● ZUM BEGINN BRAUCHT MAN
EINEN SACK FEUCHTEN HUMUS VOM WALD BODEN MIT HALB VER=
ROTTETEN BLÄTTERN ODER VOM BLUMEN HÄNDLER● GEWONNENER
HUMUS TEILWEISE WIEDER IN DEN WALD ZURÜCKLEGEN● BODEN LÖCHER
IN PLASTIK BEHÄLTER MIT EISEN ROHR BRENNEN

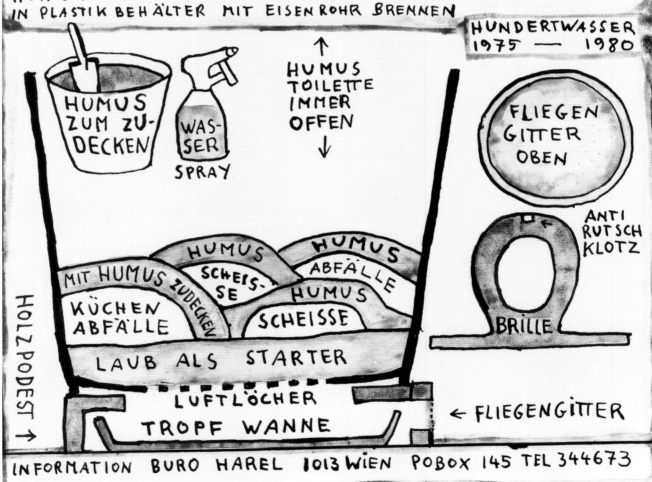

HUNDERTWASSER
1975 ⟶ 1980

HUMUS
TOILETTE
IMMER
OFFEN

HUMUS
ZUM ZU-
DECKEN

WAS-
SER
SPRAY

FLIEGEN
GITTER
OBEN

ANTI
RUTSCH
KLOTZ

HUMUS
MIT HUMUS ZUDECKEN
SCHEIS-
SE
HUMUS
ABFÄLLE
KÜCHEN
ABFÄLLE
HUMUS
SCHEISSE

BRILLE

HOLZPODEST →

LAUB ALS STARTER

LUFTLÖCHER
TROPF WANNE

← FLIEGENGITTER

INFORMATION BURO HAREL 1013 WIEN POBOX 145 TEL 344673

Information drawing for the construction and use of the self-made humus toilet

THE FIFTH SKIN: THE GLOBAL ENVIRONMENT – ECOLOGY AND MANKIND

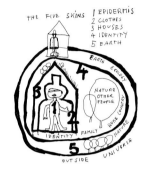

Ecology is the touchstone of Hundertwasser's sensitivity, the sensitive cytoplasm of his fifth skin. Hundertwasser is naturally "green", just as he is naturally a painter, Austrian, cosmopolitan or pacifist. Since his earliest childhood he had displayed a hypersensitivity to his surroundings. Nature is the supreme reality, the source of universal harmony; his immense respect for nature very soon aroused in him the desire to protect it against the attacks made on it by man and industry. That innate pre-destination had manifested itself as early as in 1953, with the rejection of the straight line and since 1958 in the artist's Seckau manifesto. The mould that rounds the right angles of rationalist architecture and the active ferment that starts the biological cycle of living matter, the subsequent emplacement of his theoretic corpus and its operating programme: the Window Right – Tree Duty (1972), Humus Toilets (1975), and Sacred Shit (1979) – all express his loyalty to the higher order of nature in its spontaneous regeneration. The organic autonomy of his plan had been achieved by 1980. It was to be completed in 1982 by the addition of the "water plant purification system" (ill. p. 82), a system for purifying water using aquatic plants inspired by the technique of Dr. Käthe Seidel (Krefeld). That is how the organic cycle of Hundertwasser's eco-naturist model home, the grass-roofed house, for example, works. The humus of its toilets nourishes the grass on the roof and the tenant trees of its windows. This vegetation catches the rainwater that rejoins the domestic supply circuit. The sewage

Hundertwasser with his self-made humus toilet

waters are later purified by the aquatic filtering plants. On the ecological plane, it is difficult to do better; it only remains to pasture cows on the roof, following the example set by Ivan Tarulevič's grass-roof house in New Zealand.

Evolution leads man to his ruin, declares Hundertwasser. We can let ourselves drift on, and realize that we are heading for the inevitable disaster, or we can wait for the tomorrows that will dawn after the catastrophe. If

we wish neither to let ourselves be dragged along nor to wait, there exists a third way, that of the most delicate and difficult narrow gate, of resistance, and non-violent resistance whenever possible. The system of global destruction is not lacking in faults, and they must be exploited to slow down the negative evolution and offer a reprieve to mankind. Ecology is a good delaying agent, if it is of the true, pure and naturist kind and not that distorted by the daily demagogy of green politicians.

Planting a tree is an ecological act, pulling one up is a political one. The green politicians want to dig up the trees that they did not themselves plant. For it is not so easy to plant a tree in a town. It takes a complex organization and a tenacious will. Bravo to Joseph Beuys for the 7000 oaks at Kassel, and bravo to Uriburu, the green man of Argentina, for his campaigns for annual plantations in Buenos Aires!

Since the "Inquilino Albero" operation in Milan in 1973, Hundertwasser has planted more than 60,000 trees all over the world, be it through the system of tenant-trees in architecture, on various celebratory occasions such as in Washington in 1980, at Selb in 1982 or at the IGA in Munich in 1983, and finally on the green hill at la Picaudière in France (10 hectares) and in the Kaurinui Valley in New Zealand (400 hectares).

Poster for Conservation Week, New Zealand, 1974

The year 1974 marked a decisive turning-point in Hundertwasser's public commitment to ecology. He had come back to New Zealand after having attended in Melbourne the inauguration of the travelling exhibition of his graphic work to Australian museums. He found the country in the midst of preparations for the nature-protection campaign. He joined in enthusiastically and designed the "Conservation Week" poster for it (ill. p. 80), thus inaugurating his first "poster campaign" for the protection of the natural environment. That first "committed" poster, which was followed by numerous others, is perhaps the loveliest and without doubt the most fascinating: with its round head and almond eyes, the classic head of Hundertwasser's repertoire, occupying the background space. The head is crying. The trees cross out the face and their trunks

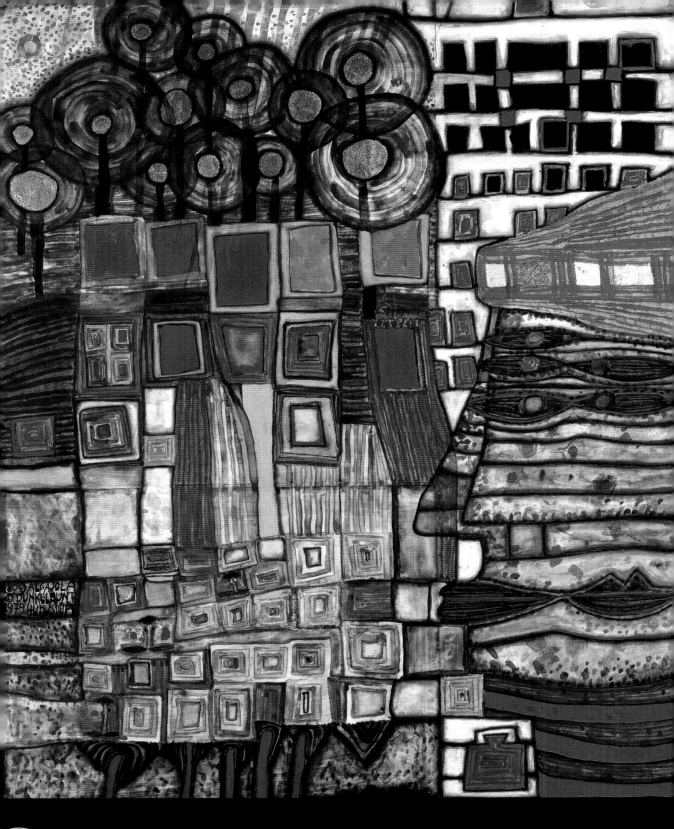

Humus Scent, Mixed media, 60.5 x 49.5 cm, Algajola (Corsica), 1979

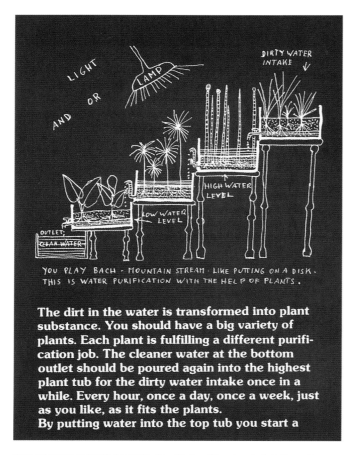

You PLAY BACH · MOUNTAIN STREAM · LIKE PUTTING ON A DISK. THIS IS WATER PURIFICATION WITH THE HELP OF PLANTS.

The dirt in the water is transformed into plant substance. You should have a big variety of plants. Each plant is fulfilling a different purification job. The cleaner water at the bottom outlet should be poured again into the highest plant tub for the dirty water intake once in a while. Every hour, once a day, once a week, just as you like, as it fits the plants.
By putting water into the top tub you start a

From Hundertwasser's letter to Alex Wade with a drawing of the water purification scheme, Kaurinui, 1982

depict the stream of tears. The poster was a big success and established itself as the keynote of the event. The "Conservation Award" conferred upon him confirmed its popularity. Hundertwasser meditated on the exemplary resonance of his gesture. It confirmed in his mind the effectiveness of the solitary glorious feat in his reformative strategy. The experience of a sensitive opening of opinion to naturist morals was for Hundertwasser a reason to take up residence in the country and to make it a regular port of call in his planetary nomadism.

The publication of his manifesto on humus toilets kept him longer in Europe in 1975. But in 1976 he rejoined the Regentag at Tahiti and embarked for New Zealand, where he stayed for a long time in the Kaurinui Valley. Here was an opportunity to meditate on his ideological commitment. The threats to nature were accumulating and the dangers of nuclear energy were growing sharper. The struggle would be a hard one. The idea of an affective boost to the heart of the planet's green lung, the Amazon forest, took its course.

In 1977 Hundertwasser, a victim of two accidents in New Zealand, spent two months in hospital at Kawakawa. As soon as he was better he went to Amazonia and travelled from Manaos up the Rio Negro, exactly one year before my own journey there with Sepp Baendereck and Frans Frascberg, which led, in the depths of the forest, to the drafting of my manifesto of integral naturalism. That experience was for Hundertwasser the confirmation of the immanence of natural order. For me, it was a revelation, and the opportunity for a profound recycling of my perceptive conscious. The conclusive accents of my text dated 3 August 1978 conveyed the depth of my emotional shock. They joined Hundertwasser's vision, which cannot but be associated with mine: "Naturalism as a discipline of thought and of the perceptive conscious is an ambitious and exacting programme, far exceeding the stammering ecological perspectives of today. It is a question of struggling much more against subjective than against objective pollution, the pollution of the senses and the brain, much more than that of the air or water. A context so exceptional as that of the Amazon arouses the idea of a return to original nature. Original nature must be exalted as a hygiene of perception and oxygen for the mind: an integral naturalism, a gigantic catalysis and accelerator of our faculties of feeling, thinking and acting."

Austria questioned itself in 1980 about its nuclear future. The project for a nuclear power station stirred a heated popular debate. Faced with such public opposition, it was dropped. This was a moral success for Hundertwasser, who had actively participated in the campaign. Another subject of satisfaction for the painter-king was the presentation of the model of Hundertwasser House, by request from the Vienna City Council. The prospect of realizing his dream, of putting his own utopia to the test of reality, stimulated his naturist faith.

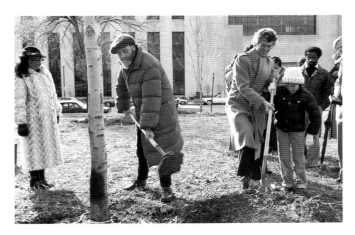

Tree-planting ceremony, Judiciary Square, Washington, November 18, 1980

It was in that exalted state of mind, after having spent the summer painting on the island of Porquerolles, that Hundertwasser flew to Washington where the mayor, Marion Barry jr., received him personally, in the company of Ralph Nader, the great ecological promoter then at the height of his glory. 18 November 1980 was declared Hundertwasser Day. The painter-king had planned to plant 100 trees in Judiciary Square. He proceeded with the plantation of the first 12 and left Ralph Nader a copy of his poster "Plant Trees – Avert Nuclear Peril" (ill. p. 83) which he had specially conceived for his anti-atomic campaign.

He also presented him with the poster "Arche Noah 2000 – You are a Guest of Nature – Behave" (ill. p. 84), for the protection of the environment ("You are a guest of nature"), which he had designed for the occasion of his participation in the second Symposium on Ecology in Berlin and for his lecture tour at technical universities in Vienna and Oslo. In Washington he multiplied his acts on the same themes: in favour of ecology, against nuclear energy and for an architecture more respectful to nature and man. It was truly a message-programme, presented and defended with passion in the form of three speeches delivered to the United States Senate, at the Corcoran Museum and at the Philipps Collection – prestigious places, resonance chambers for the whole of America, where the painter-king reaffirmed the major objective of his action: to enable man freely to exercise, in harmony with nature, his right to live in happy spaces.

Hundertwasser entered into a period of intense intellectual ferment culminating in his speech on "false art", written at Kaurinui Valley and delivered in Vienna on 15 February 1981 for the official conferment upon him of the 1980 Austrian National Grand Prize.

It was a violently controversial speech. Hundertwasser launched into a full-scale attack on contemporary art, which he qualified as "degenerate", thus infringing one of the great post-war aesthetic taboos. The radicalism of his criticism may sound abusive, but it well reflects its author's state of mind. Hundertwasser's project for society rests on beauty, the product of the creative dynamism of art. Now whilst contemporary art seems to draw closer and closer to life on the level of existential formalism, it actually moves further away from it from the spiritual point of view. It expresses its ugliness through constant visual aggression. Optical

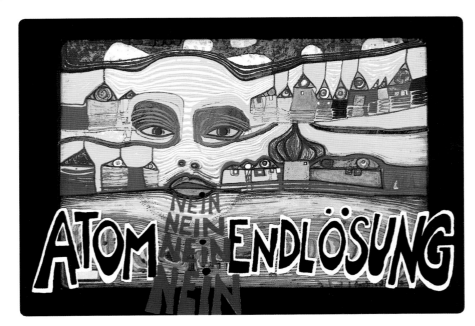

Hundertwasser poster "Plant Trees – Avert Nuclear Peril" for Ralph Nader (German version), Washington, 1980

pollution by ugliness is the most dangerous because it kills the soul. That constant attempt on the life of beauty's existential condition, the mainspring of his system, sent him into a frenzy. He exploded when he realized that this pessimistic and destructive avant-garde intended to approach the fashionable new topic of ecology, and that the Marxists whom he abhors were doing as much. This dual attitude (the avant-gardists are leftists) was dishonest and repulsive, for matters to his mind were clear: "The green revolution is not partisan and is a new evolution that follows that of the proletariat, which claims to have been the last. It is borne by the base and is neither a minority nor an élite. It is the creative evolution in harmony with the organic course of nature and the universe." In the full flight of his galloping fervour Hundertwasser sensed and dreaded the political assimilation of the greens. He pulled the first alarm signal. The opportunists of ecology, from whatever side they are on, will find him on their path, and he reaffirms his attachment to the strategy of solitary testimony: "I am tolerant. But I rebel. I accuse. It is my duty. I am alone. Behind me there is no dictatorship, no party, no group nor any mafia. Neither a collective intellectual schema nor an ideology." The painter-king's project for society is first of all his personal creation, the linchpin of his global vision of beauty, a fine work of art. His radiant power is aesthetic,

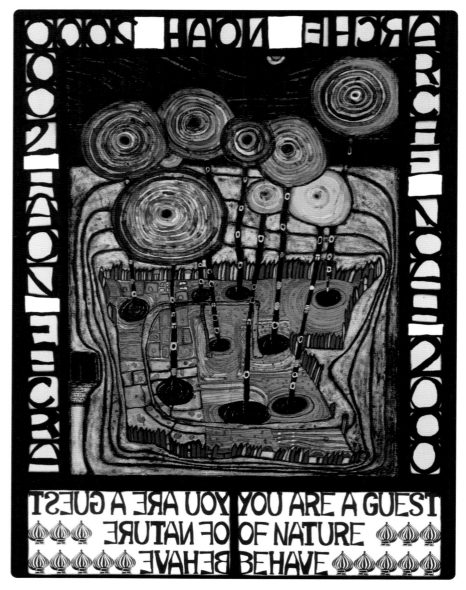

Hundertwasser poster "Arche Noah 2000 – You are a Guest of Nature – Behave", 1980

and he transmits it through the networks of the intuitive sensitivity of creative individuals and not through the formal context of a collective ideology. Ecology is the beauty barrier par excellence. Everyone finds their part according to their particular motivations. Beauty for the inhabitant of Hundertwasser House is the happy formula of public housing; for the Bad Soden resident it is a supplement to the soul in comfort; for the patient at Graz it is an improvement of his or her condition; for those taking the waters at Blumau it is the joy of health-spa life.

Hundertwasser knows the exact charismatic nature of the concepts that he manoeuvres in his polemical campaigns as in all the other facets of his creativity. His thought develops through a flow of visual metaphors expressed by speech and pen as much as by pencil and brush. He exposes his ideas to view. His talent is measured by their impact on

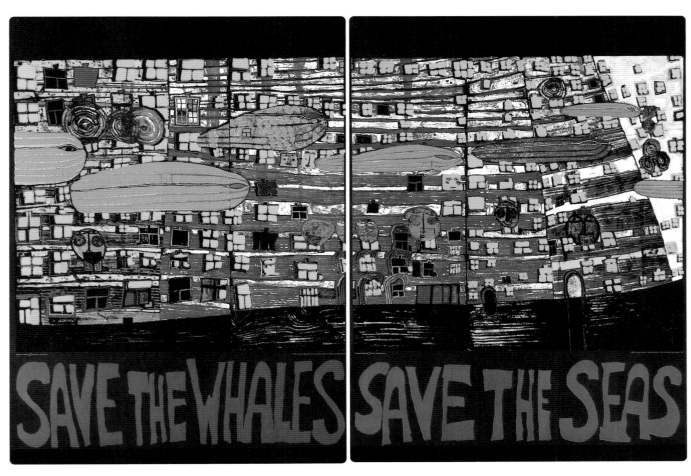

Hundertwasser poster "Save the Whales – Save the Seas" for Greenpeace Pacific Southwest and the Cousteau Society, San Francisco, 1981

the aesthetic sensitivity of individual consciences. His trump card is the retinal persistence of perceptive memory. The worldwide success of his painting is a guarantee of the growing circulation of his ideas. The painter is always there to reassure humankind. Hundertwasser is indestructible in the spiritual force of his luminous gaze fixed on the world. After all, as he is fond of repeating with Ernst Fuchs, "eternity is the domain of art". It is also that of peace, and the dangers threatening it were piling up in that year 1982. Hundertwasser was more than ever determined to call a spade a spade.

In New Zealand he took stock of the situation. He finished 16 pictures and threw himself into planetary action under the banner of art at the service of peace, as witnessed by his poster "Artists for Peace" (ill. p. 87). But his duties as architecture's doctor summoned him urgently back to Europe, where he transformed the Rosenthal factory at Selb, the coal washery at the Hamm coal mine and the Rupertinum museum in Salzburg. Once the tree tenants and the beard-tongues had been installed, he resumed his crusade for the protection of the environment. In November, he spoke at the Center of Environmental Education in Washington, where he deposited his poster "Arche Noah 2000 – You are a Guest of Nature – Behave" (ill. p. 84). Acting on a proposition by Fred Banks, director of the Harcourts Gallery, from 5 to 12 December, Diane Feinstein, mayor of San Francisco, declared a "Hun-

Sticker for "More Green in Vienna", 1980

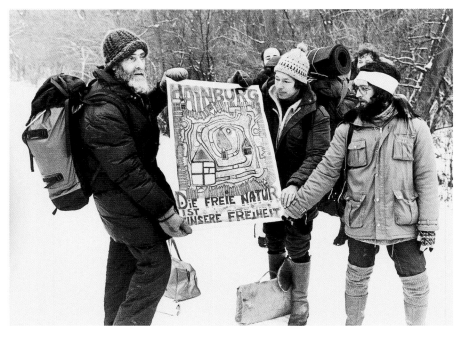

Hunderwasser with fellow sit-in demonstrators against Hainburg, 1984

dertwasser Week" in her city, on the occasion of the presentation of the two posters "Save the Whales" and "Save the Seas" (ill. p. 85) to Greenpeace and to the Jacques Cousteau Foundation. On his way back to New Zealand, he continued to spread the gospel at Seattle, Manila and Sydney. Meanwhile in October, he had treated himself to a painter-king's luxury: to go back to Paris, to the scene of his first successes, to the starting point of his spiral, and there to present, at Art Curial, an equal choice of earlier and recent works, under the title of "I am a painter – you understand – a painter – I paint with colours and brushes..."

Despite the frantic enthusiasm of his schedule, one is amazed, in those 1980s, by the extraordinary availability and minute attention with which Hundertwasser devoted himself to every least initiative in favour of the environment manifested anywhere in the world. Austria had the right to a priority treatment. He took part with equal passion in 1980 in the campaign waged by the daily newspaper Neue Kronen Zeitung for "More Green in Vienna" (ill. p. 85), and in the referendum for the safeguarding of the ancient lime tree of St Florian at Walkenstein. The pluricentenarian tree was spared. Hundertwasser exulted and dedicated a poem to it on the first anniversary of the salvation referendum. He dedicated another poem to the River Grieselbach in the Tyrol and worked for the protection of the Kamp valley in Lower Austria. In 1982, he signed the Declaration of the United Green Party of Austria. The year 1984, marked by his collection of the International Prize for the Protection of the Environment which had been awarded to him by the German city of Goslar, saw a recrudescence of his militant ecological activity. As part of the campaign "Jeder Baum mehr – eine Chance mehr" ("Every extra tree – an extra chance"), conducted in the city of

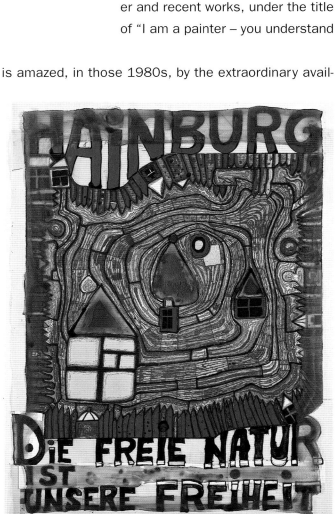

Hundertwasser poster "Free Nature is our Freedom", 1984

Graz, he planted trees on Jakominiplatz and took part in the public discussion of 16 November. But it was to the Hainburg affair that he devoted the best part of his energies. The forest and marshes of Hainburg east of Vienna were threatened by the project for a dam on the Danube. The issue quickly took on national proportions. The opposition got itself together. Hundertwasser camped out for a week on the site in the snow and did the campaign poster "Free Nature is our Freedom" (ill. p. 86). Faced with the determination of its opponents, the project was abandoned, and the painter-king cried victory.

Austria did not monopolise all his attention. In 1983 the Norwegian Minister for the Environment, with the Norwegian League for Nature, launched a campaign on acid rain and its effects on forests and fish. Hundertwasser did the poster "Save the Rain – Each Raindrop is a Kiss from Heaven", after his famous painting "Green Power", and presented it on Norwegian television on 13 October 1983. His action caused a sensation and a few days afterwards, during the press conference, he won the favour of the public who gave him an ovation when he planted his tree, in the company of officials, in front of the Akershus fortress in the heart of Oslo. The minister Rakel Surlien was to recall that event as one of the high spots of his public career.

Hundertwasser created other posters for other noble causes, such as "Use Public Transport – Save the City", which was a feat of offset printing (8 colours + metal imprints in 3 colours) and was issued in a special impression edition at the 48th congress of the UITP (International Union of Public Transport) in 1989 in Budapest; or "Survival or Suicide Rainforest", published for ECORORA in Paris on 22 April 1990, "Earth Day". But one piece stands out in particular from the abundant output of the 1980s, for the subtle charm of its poetry. "Children and the Environment" (ill. p. 87) was created in 1988 for the "United Nations Environment Program" in Nairobi, from a very early picture done in 1951, "Bird Singing on a Tree in

Hundertwasser poster "Children and the Environment", for the United Nations environment programme, Nairobi, 1988

Hundertwasser poster "Artists for Peace", Bochum, 1982

the City". The theme was taken up for a poster during the same year, "Peace with nature" for the Children's Spring Festival held at Assisi as part of the European Environment Year.

The poster thus became the most direct element of Hundertwasser's moral practice, the most effective means of awakening public opinion, the cornerstone of his campaigns. Produced with the utmost care and off-set-printed from images taken from his paintings, often old ones, the poster occupies a special graphic corner within his oeuvre, as the sensitive dial revealing every slightest tremor on his fifth skin. Conceived in real time and in situ, to meet the urgency of a given situation, the poster found its visual reference in its richly topical memories stored in the anticipatory repertoire of his painted work. Everything happened as if Hundertwasser

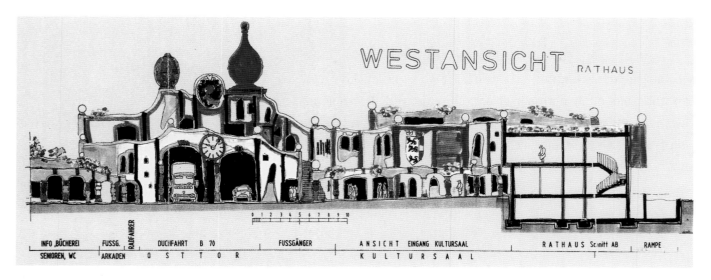

Rejected urban reshaping of Griffen 2000, Drawing by architect Manfred Fuchsbichler, 1992

had foreseen in his painting all the situations that life was to bring him up against in the defence and illustration of his project for society. His pictorial memory translates the extraordinary organic coherence of his gifted flow of intuition. With such a repertoire at his disposal, the artist has not limited his production to the illustration of the most burning issues of a strictly ecological present. He also took vicarious action through his posters at the 7th World Congress of Psychiatry in Vienna, at Europalia in Brussels in 1987 (in connection with his temporary redesign of the Palais des Beaux-Arts), for the 1995 Europe Day to celebrate "European Culture: Fantasy and Liberty". He visualized his dreams of a creative architecture, did his identikit picture of the standard European, etc. The Hundertwasser poster invaded the walls of Bochum on 11 September 1982 to witness the solidarity of artists with the demonstrators who were protesting against the installation of Pershing cruise missiles in Central Europe ("Artists for Peace", ill. p. 87). From 18 January to 1 April 1993, throughout the campaign against racism, 4000 buses carrying king-size posters by Hundertwasser (a giant silkscreen of 76 x 365 cm) travelled across America starting from New York.

Hundertwasser seized the occasion to widen his plan of action. In 1992, the year in which "Creative Architecture – Parable of Creation" started (an exhibition of his architectural models in a series of German shopping centres) and in which he both finished the model for Blumau and erected the 21st Century Clock Monument in Tokyo with a sewage treatment plant on pillars for the Tokyo TV station TBS, Hundertwasser also found time, during his stay in Vienna, to receive the mayor of Griffen and to accept his request. Griffen is a village in Carinthia, whose inhabitants were suffering from a short-sighted piece of town planning, whereby

the old village main street had been replaced by a bypass. Businesses were closing one after the other and the hustle and bustle of commercial activity had come to a standstill. What was to be done to restore to the people their dignity and habitat? The reputation of architecture's doctor and of nature's hygienist had by now reached even the remotest corners of Austria. The mayor of Griffen, mandated by his notables, came to ask Hundertwasser for a miraculous remedy. The artist agreed to present a project for the rebirth of Griffen, and drafted a plan on the spot, while studying the situation. Griffen was anxious to regain its lost soul. Was there any way of restoring the image of its identity? Griffen possessed in the Middle Ages monumental gates giving access to the central square. The gates do not exist any more and the main square had been hideously normalized and standardized. The only ace up his sleeve was to restore its heritage. Hundertwasser's plan was to refurbish the central square, build a new town hall and its green space, and

Cover design of the Bible illustrated by Hundertwasser, 1995

above all, reconstruct the main gates in the style of the Rialto in Venice, with a double commercial and residential circulation, a double row of avenue-terraces where houses would alternate with shops. The archbridge was to be at once the landmark and the living showcase of the village (ill. p. 88).

Cover design for the Stowasser Latin Dictionary, compiled in 1884 by Josef Stowasser, a remote uncle of Hundertwasser's, whose name was originally Stowasser. 'Sto' means 'hundred' in Slavic languages.

The project was presented to the local authorities and was unanimously approved by the three equally powerfully represented parties, the socialists, the Volkspartei and the liberals. But if the public was in favour, the local architects were hostile. The associations of Carinthian and Styrian architects organized a resistance and proposed a public debate on the theme "The Rebirth of Griffen. Does Carinthia Need a Hundertwasser Project?"

Hundertwasser took up the challenge and surrounded himself, to assure his defence, with Warlamis, an expert on architecture and his Eminence Zeck, of St Barbara at Bärnach, and the ecologist Bernd Lötsch. The public debate turned sharply in favour of Hundertwasser. The ball however, was in the court of the governors of Carinthia. Under pressure from the architects, they cut the funds allocated to the project for the rebirth

Cover design of the Brockhaus Encyclopedia: all lines of the 24 volumes join to make a big picture no matter if opened or closed. 1989

of Griffen. After a few years of procrastination, the project was taken up again by anonymous local architects, but to no avail.

Hundertwasser had no time to succumb to this disappointment. He was awaited in Japan, for an exhibition of his oeuvre ("Hundertwasser: His Art, Ecology and Architecture"); a monument, "Countdown 21st Century Clock", commissioned by the TBS television chain; a cycle of lectures at the Takasaki Arts Centre, and a TBS television broadcast on his ecological commitment. It was only on his return to Kaurinui Valley that he could at last get his breath back and size up the situation. He painted and worked on an illustrated Bible project that was published by Pattloch Verlag at Augsburg in 1995, thus completing his grand bibliophilic trilogy with the Brockhaus Encyclopedia (1989) and the Stowasser Latin Dictionary (1994, ill. p. 89).

Austrian environmental symbol, awarded for environmentally friendly products

One can never emphasize enough the deeply significant role played by New Zealand in Hundertwasser's psychological and affective equilibrium. Each year he returns to the end of the world to recharge his energies there. He loves the country, its nature and people. He has dedicated a book to it, "Aotearoa", from the name given by the Maoris to their land ("long white cloud"). He participates in community life there and appreciates their ecological sensitivity. He has made the "long white cloud" the port of registration of the "Regentag", symbol of his planetary nomadism. He has found his happy space at the antipodes of Vienna, in a land where grass-roofed houses don't embarrass anyone. But he cannot cease to be a Viennese and an Austrian citizen in his head and heart: it is in his native land that he has been able to lay down the tangible and lasting traces of his project for society. But Hundertwasser would not be Hundertwasser any more without this existential dualism. He goes round the earth twice a year to assume this oscillating rhythm; no one more than he has justified the possession of a dual passport.

Hundertwasser feels he is a citizen of the world in New Zealand and a European in Vienna. Observation of the New Zealand ecosystem has taught a great deal to the green urbanist, contributing decisively to his awareness of the limits and contradictions of ecology. Seen from Kaurinui, ecology remains a

(145) *Values of the Street*, Collage, 59 x 81 cm, Vienna, 1952
Composition of found objects

Drain cover grid, photographed by Hundertwasser, 1952

90

planetary concept and its local contradictions are but capillary misinterpretations. Seen from Vienna, ecology takes on a European parameter. Each ecological stance adopted by Austria affects its national independence and conditions its European destiny. Total integration with a united Europe means for Austria the irrevocable loss of its national identity, of its fundamental difference. Austria can only remain itself if it belongs to an aggregate of differentiated, autonomous, freely interacting, mutually respecting nations. Its frontiers then become its barriers of beauty. Hundertwasser rejects a united Europe and wishes with all his heart for the Europe of nations cherished by General de Gaulle.

A nationalist in Vienna and an internationalist at Kaurinui, Hundertwasser astonishes and intrigues. How can he assume two such antinomic attitudes at the same time? Art, once again, brings the answer. Hundertwasser's vision is of an aesthetic kind.

Hundertwasser is not an easel painter. He paints his canvases on the floor and contemplates them from above. He thus sees their image horizontally, ignoring the hierarchy of perspective. Each element is seen in the same measure.

The verticality of his downward sight is a manner of seeing. It commands a comprehensive view that privileges the analysis of detail in its diversity. Take a painting by Hundertwasser: it is composed of a multitude of autonomous elements minutely arranged in their coexistence. The overall image is the product of this trembling profusion of impulses and notations that obeys a biologically organic rhythm.

Hundertwasser's eye fixed on his painting is the reflection of that which he casts onto the world. His eye registers simultaneously the obverse and the reverse of a situation or an idea, the concept and its opposite, the little differences and the big contradictions.

The dualism inherent to the painter-king's nature is the reflection of the essential dualism of the nature of things. Each law of men is questioned by natural order. The painter-king does not feel this dualism as a contradiction, but as the logical effect of his manner of seeing. It is the right and the duty of the painter-king to assume the analytical verticality of his gaze.

View of the Masterschool of Hundertwasser of the Academy of Fine Arts, Vienna, 1989

From 1993 Hundertwasser's anti-Maastricht political pledge might seem to have relegated his reflection on the failure of Griffen to a secondary level of his preoccupations. Not so at all. Hundertwasser is perfectly conscious of the proliferation of points of ambiguity and contradictions that stake out the unfortunate meeting of politics and ecology.

The resistances that led to the failure of Griffen began in 1995, during the discussions on the Wald Spiral at Darmstadt. Hundertwasser's implacable enemies attacked him

on his own ground, by casting aspersions on the ecological credibility of his project: the absence of a phreatic layer and the breaking of the cycle of water supplying the roof vegetation, the malformation of the tenant trees. They attempted to oppose the naturist hygienism which rests on a perfect harmony with natural cycles, with the idea of an "honest" rationalist architecture that would be in accord with the principles of a rational ecology. The tyranny of the straight line would be exercised by delegation. The built spaces would comply to a rational code of "honest" ecology. It would be honest for the volumes of the habitat to follow the curves of ground levels, but it would be dishonest to put tenant trees into the house and doom them to the ordeal of a rickety and deformed growth.

Nonsense, replies Hundertwasser. "It won't have been necessary to wait for the Chernobyl pollution disaster to discover the hygienic virtues of chlorophyll. People house-hunting in a city worry first of all about whether there will be any trees. A tree inside the house becomes its plus-value. Real-estate agents have well understood this; they ask me to design houses for them in my own fashion so that they can sell them better."

The Disk of Phaistos, Crete. Hundertwasser's fascination with this as yet undeciphered, 3,500-year-old spiral tale caused him to imagine a new way of reading the disc line, by "turning the page" at a certain point.

The human factor is absolutely determinant. Hundertwasser gathers all the objective testimonies emanating from the users of his happy spaces: a documentation that raises his hopes of a slow evolution of society towards happiness in beauty. Throughout the warm season, a river boat offers visitors to Vienna a trip along Hundertwasser's happiness route. The "Vindobona", designed by the artist, takes passengers in an hour and a half from the house and village via the church to the museum: Hundertwasser House, the village, Spittelau, KunstHausWien. Hundertwasser House in Vienna is the most visited place in Austria, after Schönbrunn and Salzburg. Hundertwasser received the Tourism Prize in 1996. But the tenants of the Vienna house, who are so proud to live in it, are the first to complain of the influx of sightseers.

All is relative, even the barriers of beauty. An in-depth study of the man–nature relationship reveals a growth rate threshold that is the incompressible limit of ecological yield. It is the one on the basis of which the cost of the ecological effort is disproportionate to the result obtained or to the negative side-effects ensuing from it. The ecological tomato is a fine thing. But if it is produced in a greenhouse heated by a nuclear power station, the contradiction is evident. One could multiply the examples of ecological contradiction concerning, among other things, the excessive consumption of fuel caused by the transport of waste (glass, paper, plastic) when they are deposited too far from their place of incineration or from their dumps – or again the risks of pollution inherent in the manufacture of photovoltaic panels or electric batteries which can turn out to be more important than those linked to the energy systems that they are supposed to have advantageously replaced. Opossums were introduced into New Zealand on a large scale for their fur, but have become the scourge of

trees. They are killed in great numbers, but their fur is no longer taken. Their corpses pile up, decompose and create a terrible stench. The same contradiction is found in botanical imports. Kikuyu grass from Kenya was used to provide rich pastures for sheep, and the American pine to supply abundant reserves of wood, but the two species have turned out to be catastrophically harmful to the rest of the vegetation.

One cannot rely on man to respect the optimal threshold of growth. There will always be irresponsible scientists and dictators. The remedy might be education – the awakening of people to beauty through art. Students of the Vienna academy who followed the directives for the Hundertwasser Master School have done some very interesting projects, but they can be counted on the fingers of one hand (ill. p. 91). All totalitarian ideologies have used didactic power to produce the healthy man and the docile citizen.

Again a barrier of beauty has fallen. Hundertwasser takes note. It only remains for him to await the catastrophe, abundantly predicted in his painting. He does not lose hope however: "After the catastrophe, people will be able to rebuild the world in a better natural harmony, thanks to messages like mine." Starting from one of his own happy spaces, like the house in Vienna, Bad Soden, Blumau or Darmstadt, the survivors will of necessity have to approach nature. They will be able to reinstate his project for society and draw up the identikit picture of new man, an adept of beauty and of the morals of happiness in peace, as an active participant in the organic cycle of matter. That new man will freely exercise his creativity on his immediate environment surroundings, by taking up his window rights and his duty to trees. Generalized aesthetics will be his existential condition. The spontaneous creator will make his happy space a kingdom and his kingdom a paradise, and if he is tempted to go elsewhere he will need only to take a few steps to enter his neighbour's paradise.

So much for the metaphorical future of paradise regained and the splendour of the artist's pictorial vision. For the moment, the painter-king will carry on acting and creating, to prove tirelessly that art represents the indestructible link between creative man and nature, and that this link can harmoniously unite existence with essence. That tranquil force in the solitude of his visionary commitment will bring fresh manifestations of his polymorphic genius. Painting will bring forth a new crop of projects that will help us better to see and live. A few supplementary people will have access to beauty in a happy space.

Hundertwasser contents himself with this evolution by short steps in an atmosphere of imminent apocalypse, because he believes in his destiny as a painter-king. Writ large in his painting, it starts from the dangers hanging over us in the short and long term, on which he readily elaborates. Even more than nuclear pollution and the destructive power of atomic energy, he denounces genetic manipulation as the number one peril. In a hypothesis which he launched by qualifying it as horrible, Hundertwasser sees in the hybrid, half-human, half-animal creatures of ancient Egyptian, Hindu and Graeco-Latin mythologies the ancestors of today's clonings. The first genetic manipulations date back 10,000 years. That supra-natural iconography would appear to have been written in the genetic memory of mankind and to have inspired the biological manipulations of today's researchers…Yet man has no right to alter or mutilate the organic mechanisms of creation, whose universal determinism escapes his comprehension in its overall reason – and for short-sighted, selfish, megalomaniac and criminal purposes.

Hundertwasser shudders but quickly recovers. He had exorcised unhappiness once and for all on the day he was brought into the presence of his talisman. The sign of his destiny had been waiting for him since eternity; and still more ineluctably since the day in 1953 on which it made its appearance in his painting: the spiral that figures on "The Disk of Phaestos" at the Heraklion Museum in Crete (ill. p. 92), stamped in cuneiform characters on clay; an indecipherable spiral, in the image of destiny. The fifth skin of the painter-king expands to infinity.

It is fascinating to take one's leave of Hundertwasser, leaving him serenely engrossed in his art, in that privileged realm in which the fabulous sparks flying from the practical moral code of its beauty are crystallised.

Our epoch has found in the painter-king the most formidable accuser of totalitarian thinking, from nuclear energy to the organization of our living environment. He lives up totally to his way of seeing things, against the contradictions of our post-industrial society. His trump card is his art, the creator of beauty: of natural harmony, peace and joy. The extra-lucid power of his analytical sensitivity makes him the perfect decoder of global culture and its guided information. He reveals the prodigious quality resources of naturist empiricism against the abusive uniformity of rationalist totalitarianism, against the tyranny of ugliness and the iron rule of its straight line. He is on the look-out for the slightest flaw in the global system likely to bring out the latent creative urge to be found in all human beings and its effect on the quality of their lives.

The painter feels like a king in his art. The right to universal looking which he gets from it is a prerogative and duty, exercised by delivering his humanist message to the world in all the fullness and acuteness of its affective impact. No visionary and responsible creator has been so present as he in all the hot spots of our past fifty years, to make heard the generous voice of a free conscience. Wherever it is necessary to demystify an abuse of economic or political power, a technological excess, an outrage against nature, Hundertwasser is there – in the enlightening virtue of his art, in his posters and speeches. It is all inscribed in his painting, which is the revelation of sensitivity, the open book of destiny; it translates intuition into images, and those images inspire the major orientations of his thinking and action. When concretized moreover, those orientations fit perfectly into the practical norms of his aesthetic. Based on the empirical, artisan and organic intelligence of man–nature relations, his project for society is a cry of hope in beauty, a sine qua non condition for human development. Working in contact with Hundertwasser, or inhabiting his happy spaces, changes your life, as witnessed by spontaneous comments as well as official statistics.

The catastrophe that he predicts is only really the dramatization of his most cherished wish: the end of totalitarian global culture. The happy spaces already proposed today by architecture's doctor are effectively destined to ensure the happiness of a humankind at last liberated from the rational tyranny of functionalism. His project for society is aimed from now on at all those who are not prepared to renounce their individual creativity, the great existential challenge of their identity, their respect for the organic integrity of natural cycles. Such people thus strive to bring about the final triumph of pure beauty over pollutant ugliness.

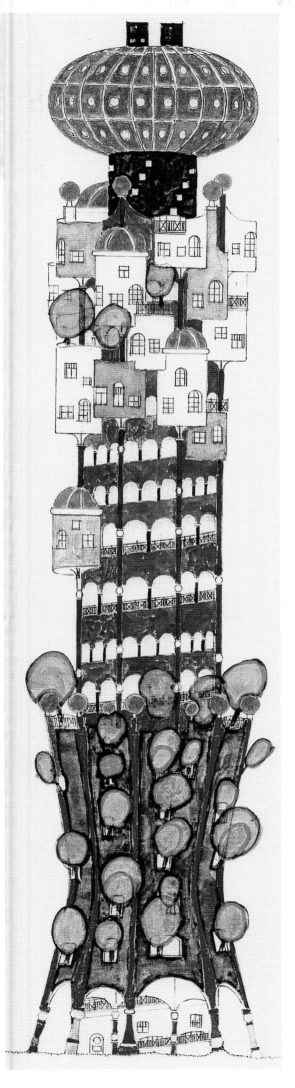

Against the globalization of a culture subservient to economics, the painter-king pits the compact and coherent resistance of an individual who has resolved to spend his life cultivating and enriching the beauty of his personal relationship with the world: through the progress of the concentric spiral of man's five skins.

Hundertwasser accounts in every smallest detail for the planetary complexity of that relationship. And I have devoted myself to a scrupulous study of it in this book. All the actions of the painter-king with the five skins illustrate the extraordinary exemplariness of an existential strategy, of a solitary testimony exercised beyond the formalist framework of collective ideologies, mafias and parties. His sole weapon is his art, conceived as the entire human potential of its creativity: a potential the results of which today, albeit partial and limited, have already proved convincing, despite the obstacles and opposition which they encounter. The number of people now living better thanks to Hundertwasser is destined ineluctably, by force of circumstances, to grow all the time.

Such is the power of art. Hundertwasser offers a dazzling and captivating way of using it; first for living, instead of surviving, and then for living better and better. The painter-king with the five skins sees the world as an ever more beautiful painting. He contrasts ruthless, galloping technology with the simplest and surest of remedies: the everlasting happiness of beauty. It is up to us to discover it, he has given us the key. Everything comes from art and returns to art.

Pierre Restany

Paris, 3 August – 6 September 1997

Hundertwasser architectural project for an incinerator for the city of Osaka, detail showing the design of the chimney, 1998

HUNDERTWASSER PAINTED A LOT ON JOURNEYS, EXCURSIONS, WHEN STAYING AWAY, WHEN TRAVELLING BY AIR, TRAIN OR BOAT, WHEN WITH FRIENDS AND DURING STAYS IN HOSPITAL

MÖDLING, WIENERWALD, DONAUKANAL, ÜBERSCHWEMMUNGSGEBIET
GREIFENSTEIN 1943 ● LEOPOLDSBERG, RODAUN, WACHAU, STADTPARK,
SCHÖNBRUNN, BRIGITTENAUERLÄNDE 1944 ● LAINZER TIERGARTEN
GARS AM KAMP, SPITAL DER BARMHERZIGEN BRÜDER WIEN 1945 ●
WUFING OBERÖSTERREICH 1946 ● DOREN VORARLBERG, BREGENZERWALD,
BREGENZ 1947 ● OBERÖSTERREICH SEMRIACH STEIERMARK 1948 ●
ANDERSEN MEISTERSCHULE AKADEMIE WIEN, SALZBURG, HOCHEGG-GRIMMEN=
STEIN, BUCKLIGE WELT, VENEDIG, LUCRINO NEAPEL, PESCHIERA,
SIRMIONE, MAILAND, GENUA, BOGLIASCO NERVI, PORTOFINO,
SIENA, FLORENZ, PERUGIA, POMPEI, TOSCANA, ROM, TAORMINA,
PALERMO, CHARENTON/SEINE, PARIS ● 1949 ● ATELIER BRIANCHON
ECOLE DES B×ARTS ▬ RETTENEGG STEIERMARK 1950 ●
MARRAKECH, TUNIS, TAORMINA, HOFGASTEIN, AFLENZ, DERNAT=
MAROKKO 1951 ● CA FOSCARI VENEZIA, LAVERNA AREZZO 1952 ●
STUTTGART 1953 ● MELIN, VENEDIG, SAN PIETRO IN VOLTA,
PESCARA, OSPEDALE SANTO SPIRITO ROMA, FLORENZ, UNIVERSITÄTS
KLINIK WIEN 1954 ● LEIBNITZ STMK, MAILAND, VEGNA VAL CAVARGNA,
(COMO) ZÜRICH, GRABESDORF, ST. KANZIAN, MARIA PFARR KÄRNTEN
CHARANENDE S&O 1955 ● ST. MAUR/SEINE, TOGGENBURG ST. GALLEN,
ST. JAKOB AM ARLBERG, STOCKHOLM, HÖGDALEN, AN BORD DER
SS BAUTA SÖDERHAMN, HULL, ● ZÖRICH, VEGNA, VAL CAVARGNA
1956 ● 1957: MARRAKECH, ST. TROPEZ, HALLERHAUS N.Ö.
LA MARNE, CANNES CHATEAU SCOTT ● 1958: ALTAUSSEE, LIGURIA
CARTAGENA, WIESBADEN, SICHTIGVOR, SALTSJÖBADEN,
KOPENHAGEN, WUPPERTAL, HÔPITAL ST. ANNE PARIS ●